VOICES FROM THE SKEENA

VOICES FROM THE SKEENA

AN ILLUSTRATED ORAL HISTORY

ROY HENRY VICKERS AND ROBERT BUDD

HARBOUR PUBLISHING

The Skeena River is the namesake of the Gitxsan people. The Skeena is the lifeblood of the earth and the people. The threat to all life on the Skeena River from the installation of liquefied natural gas pipelines is real.

The Babine, Kispiox, Bulkley, Kalum, Sustut and many other feeder rivers to the Skeena are in danger. Heavy machinery will destroy the small streams where all species of salmon spawn each year. The livelihood of people in towns all along the Skeena is threatened. Most big-industry jobs will go to workers from outside the region, as they do now.

When will we learn that the environment is what sustains us, not money and jobs? We must protect the land that has sustained us for millennia.

—Roy Henry Vickers, 2019

CONTENTS

AUTHORS' NOTE

Through interviews and audio recordings, CBC radio producer Imbert Orchard and sound technician Ian Stephen have provided us with a window into the past, allowing British Columbians to speak for themselves across time and place. Visit **http://memoriestomemoirs.ca/skeena** to immerse yourself in the original sounds of the stories in this book by listening to the speakers narrate their own experiences while you follow along with the text and art.

Among many First Nations, a feather is used in talking circles. When people sit together to communicate, the feather is passed from one person to the next. When a person is handed the feather, it is their time to speak and for others to listen. The feather symbol on the following pages indicates the beginning and end of an audio clip, as these voices from the past take their turns speaking into our present. We encourage you to listen along.

PREFACE

In 1959, Canadian Broadcasting Corporation radio producer Imbert Orchard embarked upon a seven-year journey to record, as he called it, "the story of the province." He recognized that the non-Indigenous population of what is now British Columbia had swelled from approximately a couple hundred people in January of 1858 to over 400,000 by the First World War. He knew that the people who lived through these changes were starting to die, and he took it as his mission to record the stories of as many of them as he could. In doing so, he ended up recording 998 people and amassing one of the largest oral history collections in the world.

With sound technician Ian Stephen, Orchard criss-crossed the province talking with totem carvers, road and railway builders, miners, homesteaders, farmers, ranchers, artists, lighthouse keepers, sailors, merchants, officers and so many others. The more than twenty-seven hundred hours of recordings are a remarkable resource and a fascinating and crucial part of British Columbia's history. In fact, Orchard was able to produce two hundred radio programs from the source material and mused that he used on air less than 10 per cent of what he and Stephen had recorded.

Voices from the Skeena is a direct result of these recordings, which brought the two of us together. Roy recalls, "When I was a teenager, I was moved from my home community of Hazelton on the Skeena River to Victoria for high school, where I encountered discrimination for the first time. I realized discrimination is ignorance, and I felt I needed to teach people about the beauty and richness of my father's people and the lands they came from. I began to study my ancestors and their art and culture. My art teacher, Mr. William West, directed me to the Victoria Public Library, where I found the writings of the anthropologist Franz Boas who did fieldwork in Indigenous communities on the Northwest Coast, and then on to the provincial museum in the legislative building, where I found the stories recorded by Imbert Orchard and published in a quarterly magazine called *Sound Heritage*. I loved listening to the old people and stories of the Skeena River in those recordings, and they helped me stay in touch with my home country. I also met the anthropologist Wilson Duff at the museum, and he set me on the path of learning about art and culture that I continue to walk today."

"On October 22, 2012, I received an email from Roy introducing himself," remembers Robert (Lucky), "and asking about recorded oral histories of the Skeena that he had heard at the Royal BC Museum in the 1960s. In the summer of 2000 I was hired by the CBC and the BC Archives to thread those tapes up and digitize them. I have always had a deep passion for stories, storytelling and recording, but just one week into my contract that first summer I picked up a tape labelled "Patenaude–Horsefly" and immediately I realized that I was sitting on a treasure trove of recordings: here were people's ancestors, speaking in a language they could understand, about places they knew. Among my closest friends is Pharis Patenaude (now better known as the Juno Award–winning

singer-songwriter Pharis Romero) who is fifth-generation from Horsefly, BC. The tapes in my hand held recordings of Orchard speaking with her great-great-grandfather and great-great-uncle, who were among the first non-Indigenous settlers in the Cariboo region. Pharis's family had no idea these tapes even existed! I knew in that moment that I could not simply leave the recordings I was processing as mere finding aids for the collection. I was inspired to bring this material back out into the world: first I made the collection the subject of my master's thesis, then I began to share these stories in books and through a radio series on the CBC. This expertise meant I knew where to find the exact recordings Roy was looking for!"

"These days," says Roy, "my research has brought me back to the north, guided by my love of the land, the culture and the people. As an Elder in my community, people often seek my knowledge and I continue as a teacher. When Lucky and I spoke on the phone after he received my email, we hit it off immediately. We decided we should meet in person when I was next in Tofino, and we agreed that day to begin working together on my biography."

And as we started on that project, the sparks really started to fly and we got excited about all the books we could do! For a while we got sidetracked telling the beautiful stories in the Northwest Coast Legends series. These stories come from Oral Tradition and have been passed down from generation to generation, evolving over time. First came our illustrated book *Raven Brings the Light* (2013), and then *Cloudwalker* (2014), *Orca Chief* (2015) and *Peace Dancer* (2016). Every time we got together to work on those books, we continued to come up with many other exciting ideas and projects

and we often talked about our shared love of Orchard's stories.

It seems logical now to think that we'd make the leap from Oral Tradition to oral history, but ironically it took a few years for the idea to seed itself. And when it did, we both hit on the idea at the exact same time! *Voices from the Skeena* is a journey that began with Imbert Orchard in 1959, was passed along to Roy in the 1960s and then entrusted to Lucky in the early 2000s. All of us have come together in this book to pass along these stories to you. Remember, these stories were spoken and are meant to be heard, so we encourage you to listen along with the audio while you follow along with the text and take in Roy's images.

"Today I live beside the Skeena," says Roy. "I fall asleep and wake up to the whispers of the Skeena, I love to ride the Skeena in a canoe, a raft or sometimes swimming. Time on the river is healing, cleansing and renewing, and it connects us with those who've gone before us. It's that connection that I bring to my art—I continue to love and learn and teach the world about rich Pacific Northwest cultures to this day—and our reason for wanting to share these stories." Adds Lucky, "I was familiar with all of these stories before we began working on this book, but watching Roy breathe new life and colour into this period of history that has mostly been fading into obscurity has made me see these stories in a whole new way. It feels as if daylight is illuminating these places for the first time in over one hundred years and bringing them back from the shadows. Enjoy the journey!"

—Roy Henry Vickers and Robert "Lucky" Budd

INTRODUCTION

The Skeena starts high up on the Spatsizi Plateau in northwestern British Columbia, in a valley between Mount Gunanoot and Mount Thule called the Sacred Headwaters. From this area of rolling grassy tundra that is the traditional hunting grounds of the Tahltan people, the river flows 570 kilometres to the Pacific Ocean, making it the second-longest river in BC. To the Tsimsien and Gitxsan people who have lived alongside the river since ancient times, the Skeena is an essential transportation artery; the communities depend on the health of the river. They understand that the fish, vegetation and wildlife are interconnected. Today, the Skeena remains one of Canada's pristine rivers. Its strong currents, boiling rapids and narrow canyons are as challenging to navigate as they have always been, and it is with good reason that the Skeena has earned the reputation of being the toughest navigable river in North America. Our goal in sharing these stories is to reveal the Skeena as a national treasure.

The Indigenous people of this area have creation stories that are as old as the tides that rise and fall on the shores of the Skeena. There are stories of the flood. There are stories of the world in darkness before Raven brought the sun, moon and stars to light the world. But the stories in this book begin with the arrival of the first Europeans to the west coast of Canada. It was the fur trade that brought explorers to BC, and in the 1800s the Hudson's Bay Company built their trading post at Fort Simpson, where the present-day community of Lax Kw'alaams (Port Simpson) is located. The Omineca gold rush brought more travellers to the north, all of them chasing their dreams in the mountains east of Hazelton. The First Nations thought the settlers were poor, so they offered, "Build your store here." This speaks to the inclusivity of the First Nations people. To this day the pieces of land that were given to these settlers are removed from the reserve. Port Essington and Hazelton were the destination for yet another wave of people who were helping to build the Collins Overland Telegraph line, a trans-Canada highway and the Grand Trunk Pacific Railway that was on its way to a new town called Prince Rupert.

Hazelton became the hub of much of the activity in the north. It was the destination for canoes, and later for sternwheelers delivering goods from the south, and pack trains were always waiting to take these goods to any of the various destinations in the North Country. The people Imbert Orchard recorded recall the days when the large Haida canoes were used to navigate the river through to the heyday of the paddlewheelers. It is this short period of BC's history, roughly between 1895 and 1912, that we highlight in this book.

Sixteen different paddlewheelers navigated the rough waters of the Skeena from 1864 to 1912. The first of these boats, the *Union*, made the trip up from Victoria to the mouth of the Skeena in 1864, carrying four passengers and twenty tons of freight. However, the trip was declared a failure when the captain, Tom Coffin, decided he could not ascend the river without more preparation and so the boat and its crew returned to Victoria. The *Union* was hired by the Collins Overland Telegraph Company to try again in 1865, but this trip revealed the draft of the *Union* was too deep for the Skeena. The telegraph company decided that it needed a new vessel to work its way through the tough water.

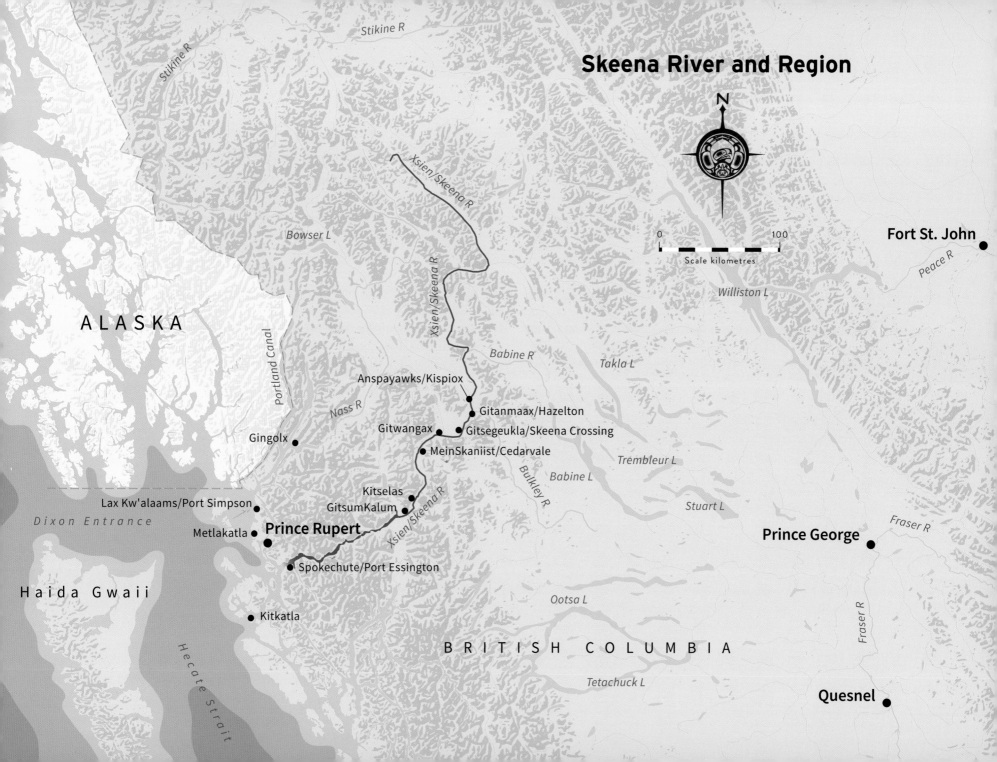

Skeena River and Region

N

0 100
Scale kilometres

Fort St. John

ALASKA

Stikine R

Stikine R

Xsien/Skeena R

Bowser L

Xsien/Skeena R

Williston L

Babine R

Takla L

Portland Canal

Nass R

Anspayawks/Kispiox

Gitanmaax/Hazelton

Gitwangax

Gitsegeukla/Skeena Crossing

Gingolx

MeinSkaniist/Cedarvale

Trembleur L

Bulkley R

Babine L

Kitselas

Xsien/Skeena R

Stuart L

Lax Kw'alaams/Port Simpson

GitsumKalum

Dixon Entrance

Prince Rupert

Prince George

Fraser R

Metlakatla

Xsien/Skeena R

Spokechute/Port Essington

Haida Gwaii

Ootsa L

Kitkatla

Hecate Strait

B R I T I S H C O L U M B I A

Tetachuck L

Quesnel

The following year, Captain Coffin made three separate trips in the newly built paddlewheeler called *Mumford* to deliver twelve thousand rations for the workers establishing the telegraph line. It was not a comfortable journey for passengers, as they were given axes and bucksaws and told to chop wood to feed the enormous boiler that kept the boat going. However, the Collins Overland Telegraph Company went defunct once the transatlantic telegraph cable was completed that year, the *Mumford* returned to New Westminster where it was docked in October, and it was never used again.

Three years later, in 1869, the Omineca gold rush made navigating the Skeena profitable again. Canoes were used to travel up the river to Hazelton, where a 185-kilometre trail went overland and made its way east past Fort Babine and Takla Lake to the Omineca River. This route is known today as the Babine Trail.

In 1889, the Hudson's Bay Company built a sternwheeler called the *Caledonia* to make the trip up the Skeena. Captained by George Odin, the *Caledonia* launched in February 1891 and made her first trip to Hazelton in May of that year, a journey that took nine days. Captain John Bonser was hired to be her captain shortly thereafter and he saw to it that she was overhauled in 1895 to make her more manoeuvrable. Incidentally, Captain Bonser named eleven canyons and rapids along the river, giving them names like Devils Elbow, Graveyard Point and The Whirly Gig Rapids. The original *Caledonia* was replaced by another *Caledonia* in 1898 (designed by Bonser himself), when the Klondike Gold Rush was in full swing and many more people flocked to the north.

The railway to Hazelton was completed in August of 1912, which signalled the end of the steamship era. The *Inlander* left Hazelton for the last time on September 13, 1912, under Captain Bonser, and once the boat reached Port Essington it was brought ashore. Captain Bonser died the following year on December 26, 1913. The Skeena River, born in the mists of time, continues to flow from the mountains to the sea, a majestic icon of the north.

NAVIGATING THE CLOUDWATERS

CHIEF JEFFREY H. JOHNSON ON THE LIFE OF THE GITXSAN
AND TSIMSIEN ALONG THE SKEENA
(RECORDED APRIL 2, 1963)

One of Roy's favourite recordings from the Imbert Orchard Collection is this one with Chief Jeffrey H. Johnson (b. 1897), who carried a Chieftainship from Kispiox (or Anspayawks, "The Hiding Place"). Johnson explains how he looked for the Gitxsien name for the Skeena River for a long time, and finally he found an old woman from Kitkatla who told him the name, which is interpreted as "the moisture from the clouds," or as Johnson said, "the juice from the clouds." Today, says Roy, the word is spelled Xsan in the Gitxsan language (Gitxsanimix) but the more accurate phonetic spelling, when you hear the word spoken, is Xsien. It is a part of the name we call ourselves: the word for "people" is spelled Git, and so the word for "the people of the Skeena River" is Gitxsan (or, as I prefer, Gitxsien).

Although Gitxsanimix is the language spoken on the Skeena River today, it is a dialect of the old language Tsimshian, which is more accurately spelled Tsimsien and is interpreted as "in the moisture from the clouds" or "in the rain." This word, Xsien, is connected to our word for "clouds," which is Yain. We call the moisture from the clouds Wxsyain. The language is difficult to learn as it requires attentive listening and then working at repeating the sounds. It is still spoken by many people but the literal meanings are lost because it is being spoken by people who think in English and give interpretations of the words that are far from the literal meanings. Already in Chief Johnson's time, the literal meanings and names of our words were being forgotten.

My grandmother Kathleen Vickers, who was a Kitkatla woman, helped me understand the loss of meaning in language. I once asked her why we use two different expressions for "I don't know." It took a long time for her to explain that one expression literally translates as "they are not in my heart" and is used when speaking of people. A different set of words literally translates as "there are so many leaves on the ground I can't tell which one is which" and is used when speaking of objects. What I have come to understand is that language is a part of our culture, and a greater part of culture is our relationship to our environment. Know the environment and you will have an understanding of the culture.

Opposite: Xsien (Cloudwaters)

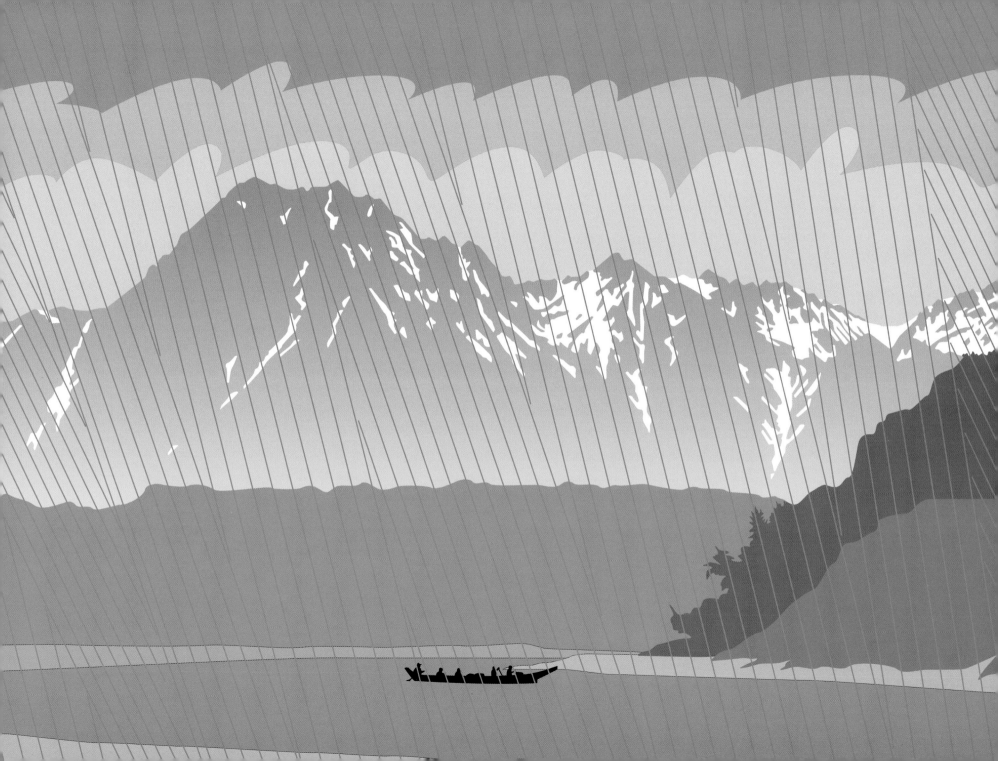

IMBERT ORCHARD: What is the Native name for the Skeena River?

CHIEF JOHNSON: The Skeena is, in the old language, they called it Xsien. Xsien. And the meaning of that is "the juice of the clouds." That's Xsien.

Do you know that cloud, or the fog comes from the water, isn't it? Well, that fog is letting the water out in the Fall. Well, that means "the juice of that cloud" or "a fog" makes the river stronger.

I've been trying to get this Xsien for a long time with the olden people, you know. Some of them said different things altogether, and I don't [feel] satisfied with that. And I went to another man and asked him, "What's that meaning of that Xsien?" Well he said this and that, you know. It doesn't seem to me [it] would be true. And at last there's an old woman down here, Kitkatla. That's the woman that explains the name of the Xsien.

Because those people they were up this side Kitwanga [Gitwangax]. They used to live there for fall-time, making food for the winter, you know: berries and fish and all things like that. And after the fall fishing for them, they went home. So that's how they know everything in the old language up there.

Opposite: River of Mists

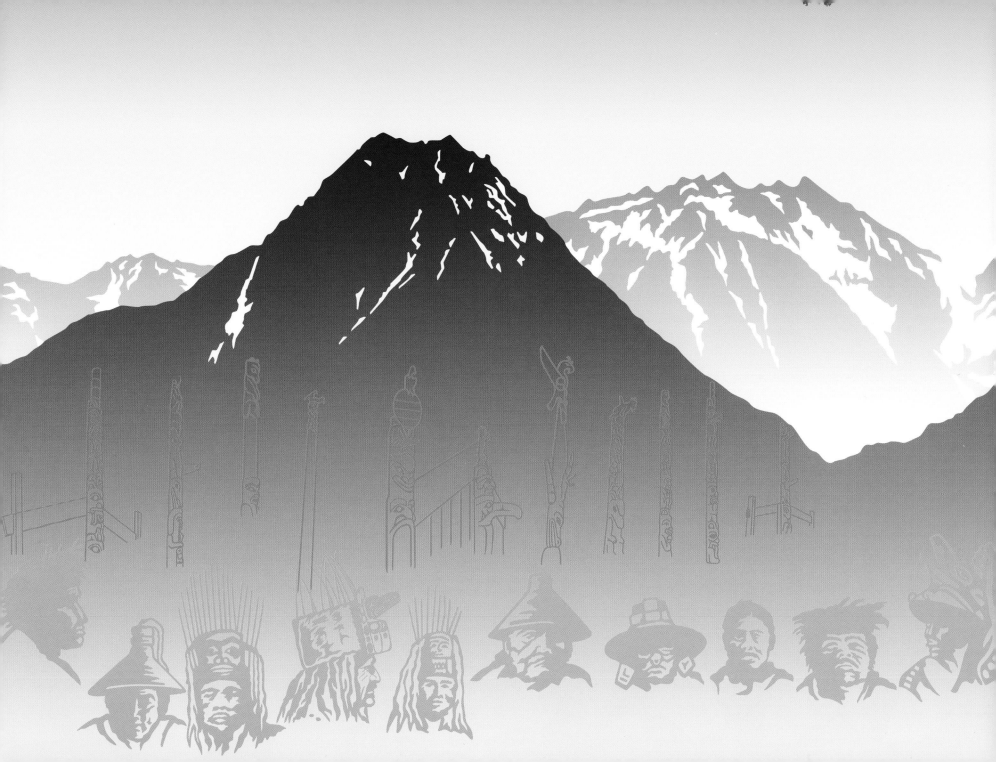

In those times before the white men came in, they made their own traps for wood. They were trapping something like marten, and fishers, and the bear, they used a snare to kill the bear. No gun, no nothing. And what they do with the skin, they tan it and make coats out of it, out of those martens and other things. And mountain goat; they used snares for that. And they used the meat and they used the skin too. They tanned that skin of the mountain goat and used it as a blanket. And it's very, very warm blanket, better than the Hudson's Bay's. Heh heh.

———

Opposite: Fur Bearers

And when the white mens came in: the Hudson's Bay peoples was the first people, and then the churches, missionaries. As they call it now, United Church, it's the first church that came to the Skeena. And then the Anglican, and then the Salvation Army. Those three. And then churches they have further up toward Smithers, in Moricetown, it's all Roman Catholic. And then from Hazelton this way is United Church and Anglican and Salvation Army.

Opposite: St. Mary Magdalene in the Wet'suewet'en Village of Hagwilget

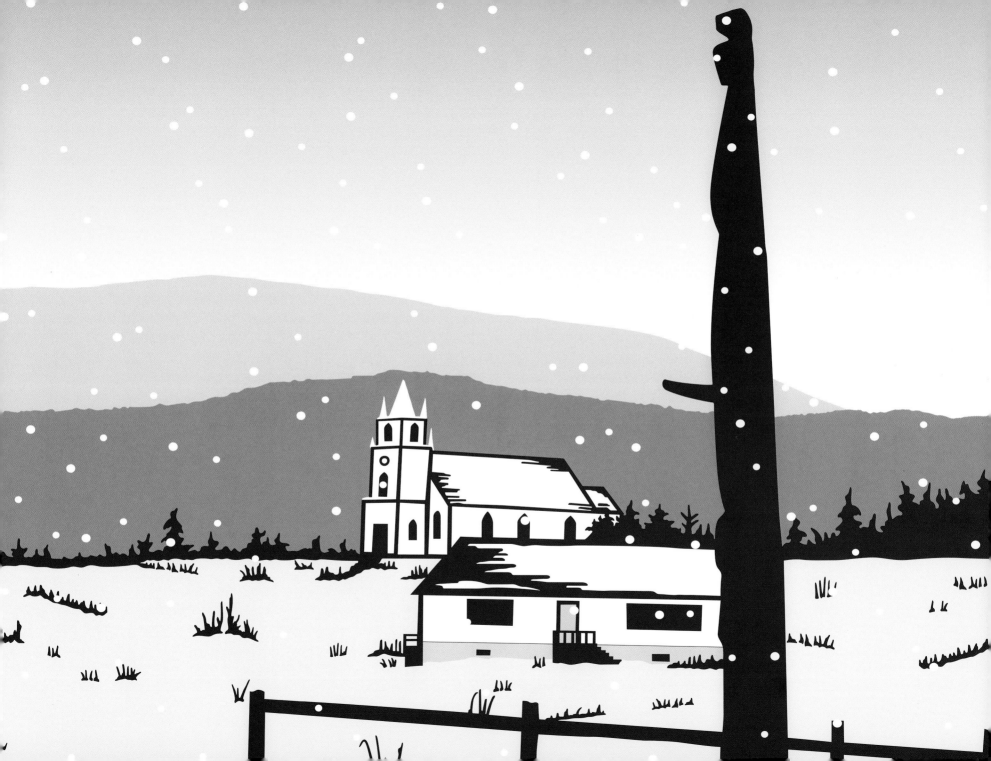

And besides that it was smallpox. I forget what year it is when the people cleaned out down the Skeena, and there was very few people left when I was a little boy. Not many young people, not many older people, because of that disease was cleaned the people out.

They say the Hudson's Bay taking the freight up to go to Babine and it came so late in the fall and it stored in the store at Hazelton, those stuff that had to be shipped in around Babine. That's how the smallpox starts: any of these people buying sugar, because they like that sugar at that time, you know. Not many before. So they buy those sugars, and that's where the diseases comes and spread among the people and cleaned the people out. That's the time of the Hudson's Bay. They don't like to say anything about it because they're scared of the law. They don't know what to do or what to say in regards to this, you know. They just kept it down because they can't fight it. They can't do anything because they don't know how they can handle it to the law.

Opposite: Old Ways Are Forgotten

Now before that, when the people lived before the white people came in, and there's nothing for them to do for a living except what they made by themselves. There's no vegetables until the Hudson's Bay came in and brought in the seeds of potatoes. The store man, he said, "It's a good seed!" He said, "It's a good seed!"

Well that Native heard that, and he turns it a little bit different. He thinks that's the name of that stuff is Skooseet, he said. Heh heh. And that's how the name came into being in our people and we still use that Skooseet now.

ORCHARD: The Skooseet means what?

JOHNSON: Potatoes. Heh heh. This white man said, "It's a good seed," he said. And when this man hears it, and he said, "Oh, that's the name of that stuff!" And he said, "Skooseet!" Heh heh.

Opposite: It's Good Seed (Potatoes)

Now in those days, these canneries: the first one, Father told me, Metlakatla, Duncan's. It's the first cannery built, and then later on the Inverness. They travelled by canoe from upriver. Four or five families to one canoe came down here early in the spring. And what the canneries use, they used wood to cook the fish, you know. And the womans working in the canneries and so on like that.

They travelled by canoe every spring and every fall. Those womans at the cannery, early in the spring, they're knitting net and there's cartons of a twine. I think a woman gets two and a half for one carton to knit a net. All the womans that came down does that work.

During the summer when the canning was on, the womans get three cents a tray filling the cans, hundred and fifty trays to a ticket. That's a lot of money for them, because it's an awful lot of fish in those times. Mother used to, she used to make a ticket a day, and they were surprised in how much money she get for seven fifty a day for that ticket, you know!

Fishermens, they don't sell the fish by each fish, the same as we do today. They only pay by the month: thirty dollars for a captain, and twenty-five for boat-poler. And it's only two months in the year they fish. They fish day and night for that thirty dollars a month. They used a flat-bottom skiff. There's no shelters, just open skiff, flat-bottom skiff with two pieces across to sit on. You know how much wind and how much rain we have here, and these people would sit out there in the rain and wind blowing.

The groceries were awful cheap at that time. I remember forty-nine-pound sack of flour is a dollar and a half in those days. And denim pants was seventy-five cents, that's what they pay.

AND THEY POLED FOR ALL THEY WERE WORTH

—

VICKY SIMS ON TRAVELLING THE SKEENA BY CANOE
(RECORDED FEBRUARY 8, 1962)

Victoria "Vicky" Sims (née Morison, b. 1887) was born in the Christian mission village of Metlakatla. Her mother, Odille Quintal (1885–1933), was half Tsimsien and half French Canadian and was a highly respected Tsimsien interpreter, nurse, teacher, entrepreneur, mother and wife, who even assisted ethnographer Franz Boas. Sims describes the community of Meltlakatla as a beautiful little cathedral town, and her parents as "great warriors for the Church of England."

Sims' entire childhood centred around life at the missions in First Nations communities on both the Skeena and Nass Rivers. While the family lived in Metlakatla, her father would relieve the clergy when they went on holiday. Sometimes the entire family would join him. Sims lived for a time in Kincolith (present-day Gingolx) on the Nass River and joined the Nisga'a community there to collect oolichan at their fishing grounds at Fishery Bay. Later, Robert Cunningham, the former missionary turned trader, asked her father to move to Hazelton and run his business there, and Sims spent her winters in Metlakatla and her summers in Hazelton for the sternwheeler season.

The following story takes place in 1897, when the *Caledonia* only made a few trips up the Skeena River. When the sternwheelers could not navigate the river, people travelled to Hazelton by canoes poled by Indigenous people, just as they had been doing for centuries. By the time she was ten years old, Sims would have been up and down the river many times and she remarked on how much she and the other children enjoyed the return trips when they "ran the rapids." The canoes must have seemed very large, but even the biggest canoes, fully loaded with passengers and cargo, would have weighed less than fifty tons, as Sims claimed they did. Perhaps she was exaggerating. Roy recalls, "Before being hollowed and shaped, a ten-metre length of cedar tree that I carved weighed 17,500 pounds, or just under nine tons."

Opposite: Poling Upriver

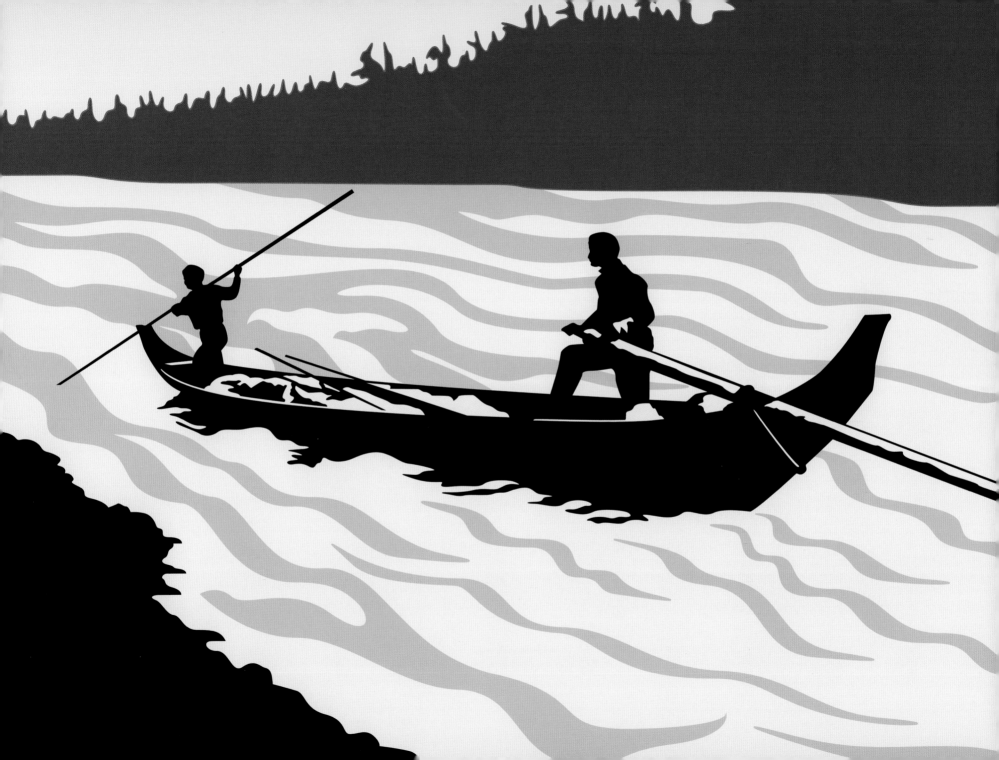

IMBERT ORCHARD: Now would you like to describe what it was like going up the Skeena River in those days, how you went up the river the first time?

VICKY SIMS: Well we went by canoe first in '97 when all travelled by canoe 'til the *Caledonia* just made two, three trips.

We had to go. It'd be manned by five men. They just paddled from the time they left Port Essington, you know, and just paddled, paddled their way up until they came to the river and then they used poles, you see, and paddles when necessary. You know, crossing the river.

And I remember when we just got to tidewater, you know, as far as we could go. These men jumped out with these things they used to wear, I don't know what they were, you know—burlap, you know—and they'd fasten it and haul on the canoe. And I remember I burst out crying, I thought they were going to be drowned. One of the boys said, "Gus sem'peh, don't mind," he said, "you'll see this all the way to Hazelton!" And that's how we travelled, poling.

They get into shallow water and the Skeena is so swift, when you come to those ripples, you know, that they have to get out and haul on them just like mules. You know, they put these things on and then crawled to shore, and just crawled on their hands and knees and pulled the canoe over the rapids. Then they jump in and poled again for all they were worth. In and out. They were never dry.

ORCHARD: What were they wearing?

SIMS: Just ordinary clothes. Yes, they didn't mind. They just went on and on, they were so accustomed to it.

ORCHARD: They wear boots?

SIMS: Oh yes! Oh yes, because there were all pebbles up the Skeena River and rough rocks.

We thought it was fun when we'd cross: they paddle, they'd sing. It was really beautiful. They'd have their own songs they'd sing, and mark time you know, and paddle all in unison. It was really wonderful.

———

Opposite: Lining the Canoe

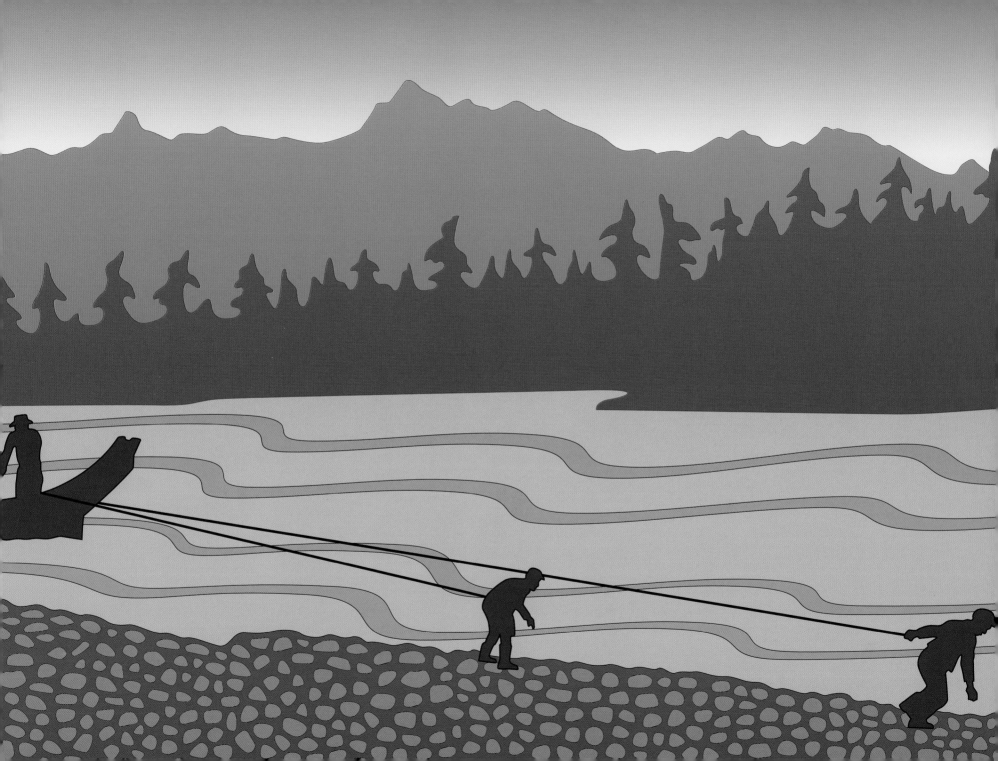

And then to cross, you know, to avoid bad ripples? Oh, they were all Native songs. And we'd laugh and Mother would turn white, you know. She said, "When you grow up and have children of your own you'll realize the danger." Of course we didn't, children don't. We loved the fun. Yeah.

But they were a jolly crowd, they were always singing and fooling. Yes, they liked the work.

They had fifty-ton [sic] canoes, those lovely big Haida canoes. And then they build quite a comfortable place in the centre of the boat. You paid for half. Cost a hundred dollars to go to Hazelton then, and you paid half for the section that you use as sort of a passenger quarters.

ORCHARD: Did it have a cover over it?

SIMS: Oh yes, just canvas, you know. They did when it would rain. Otherwise we never bothered. People were hardy in those days!

And then, of course, they pitched tent every night. And that was the bowman's job: he pitched tent, lit a fire, got everything ready and cooked. He was the cook; he was everything. The bowman, very expert men; they were just wonderful.

And we arrived in Hazelton. Flags were flying; they made such a fuss, you know. They were so pleased to see us arrive safely for the winter.

See, there were so few families there that just one family away meant an awful lot during the winter, you know, for entertainment and that sort of thing.

Hazelton was in benches. We had the whole lower flat, for the white people. And then the next bench was the rancherie, as we called it. That meant the Indian reserve. Yes, rancherie. It was just, we had the whole flat, you see.

And dogs. Dogs by the thousands because they used them for commercial purposes, you know. That's one of the things I used to do. In the early days we were quite close. There was a church and then our house. And I would open the window in the moonlight and I started to howl like a dog and I'd start the whole rancherie. The dogs would howl. My father used to be cross. He'd say, "Will you stop that nonsense?!" But I really loved listening to them, you know.

Opposite: Howling Dogs at Gitanmaax

And then we used to watch the old medicine men. Just peeps through the cracks but of course we were stopped. They didn't like it. It was so sacred to them, you know.

It was very quiet until the miners came into town from the Omenica and Ingenika and all those parts. And such a lot of Chinamen! They made their winter quarters in Hazelton, and then of course Mother loved that sort of thing. She used to work amongst them and we always had Thursday nights, you know, together at the house. And they did enjoy coming to the house and sing[ing].

And we used to then in the spring, March, the miners headed for the gold grounds then, and we'd always accompany them to Two Mile. Such a group, you know! And they all carried great poles, for walking, to support them in walking. And we'd go along with them and that was the parting of the ways, and we wouldn't see them again until the autumn.

They had Indian packers. The Indians were wonderful packers in those days; they carried everything on their backs—the women too, you know.

There was an old man; they used to nickname him Chickens. He carried a stove on his back. He was a little bit of a shrimp, you know, but oh such power! You know, they were so accustomed. And their dogs—they even used to pack their dogs in those days and rig their little saddlebags on either side that they fill and the dogs would carry things. Everything was done by the people. And then they would go on their way and we'd return, all on foot, you know.

———

Opposite: Backpackers

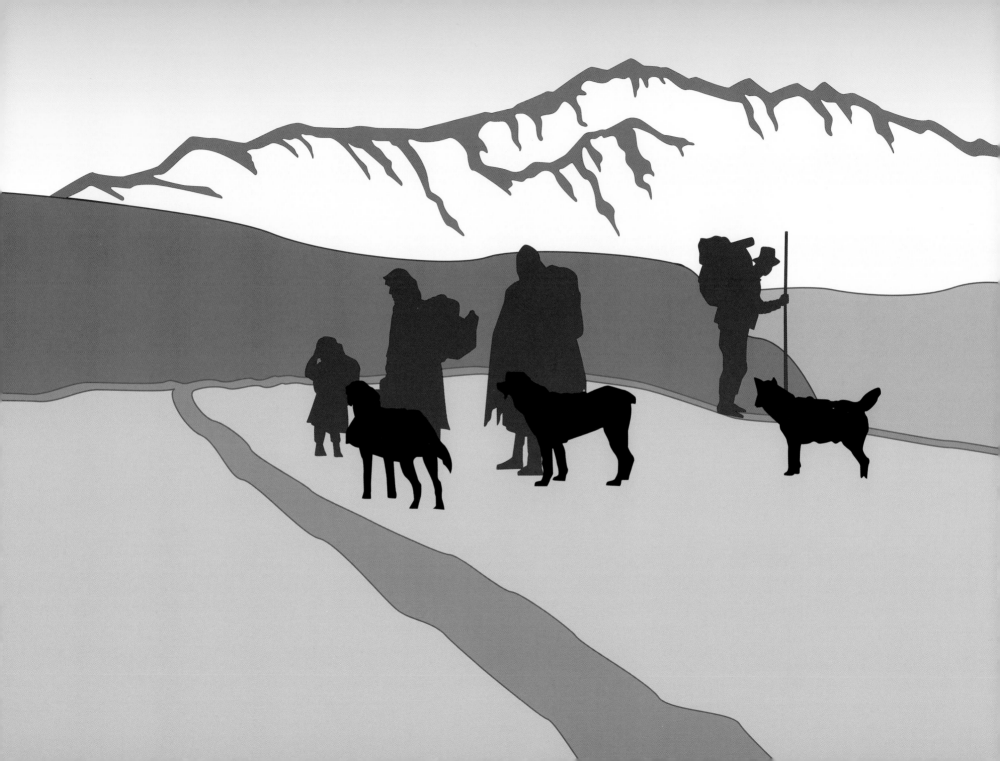

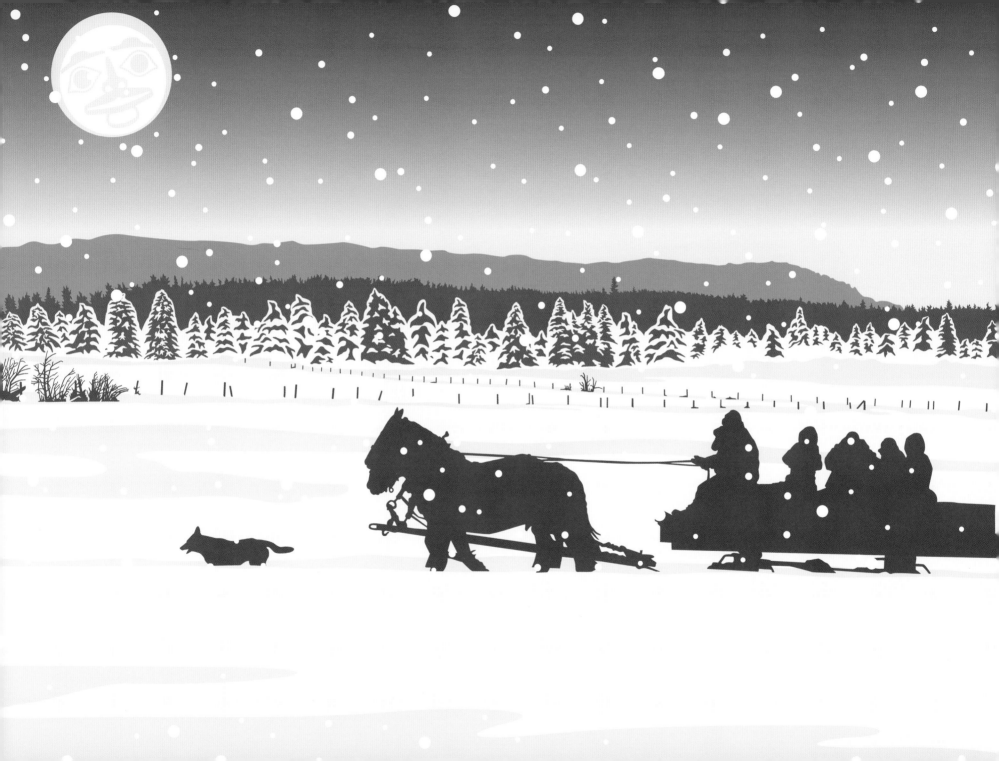

'Course we had some wonderful days sleigh riding, you know. Fill up the big sleigh with straw and these lovely groundhog robes. They were lined with scarlet Hudson's Bay blankets, you know. And we'd sit there and the driver would have a couple of horses and sleigh bells. It was a wonderful life in those days: skim along for miles and miles.

Opposite: Two-Horse Open Sleigh

MORE TRADER THAN MISSIONARY

AGNES HARRIS ON ROBERT CUNNINGHAM AND
THE FOUNDING OF PORT ESSINGTON
(RECORDED FEBRUARY 8, 1962)

By 1871, the Skeena River was beginning to show signs of becoming a busy travel network. The Christian mission at Metlakatla had been established nearly ten years earlier, and the trading post at Port Simpson (Lax Kw'alaams, "On the Place of Wild Roses") was well established. Members of the Tsimsien First Nation would navigate the river in their giant canoes to trade with various other nations along the river, or to take goods and passengers to and from the settlements.

In 1862, at the age of twenty-five, Robert Cunningham (1837–1905) came to Canada to work with William Duncan at Metlakatla. Two years later, Cunningham left the mission to work for the Hudson's Bay Company (HBC) at Fort Simpson, where he became chief trader before leaving in 1870 to found Port Essington on the south bank of the Skeena River where it meets the Pacific Ocean. In the 1890s, Port Essington became the largest town in the area, and salmon canneries became the main industry.

Our people call this site Spokechute, says Roy, a name that translates to "Autumn Camping Place." It was also referred to as Cunningham's Town, and it was here that Agnes Harris (b. 1885) came to live in 1905 after she married her husband, Arthur George Harris, whom she'd met while he was visiting his family in England. Arthur Harris had met Robert Cunningham during his first trip to Canada in 1889, and their friendship was one of the reasons that the Harrises settled in Port Essington. The Harrises eventually moved to Vancouver in 1921.

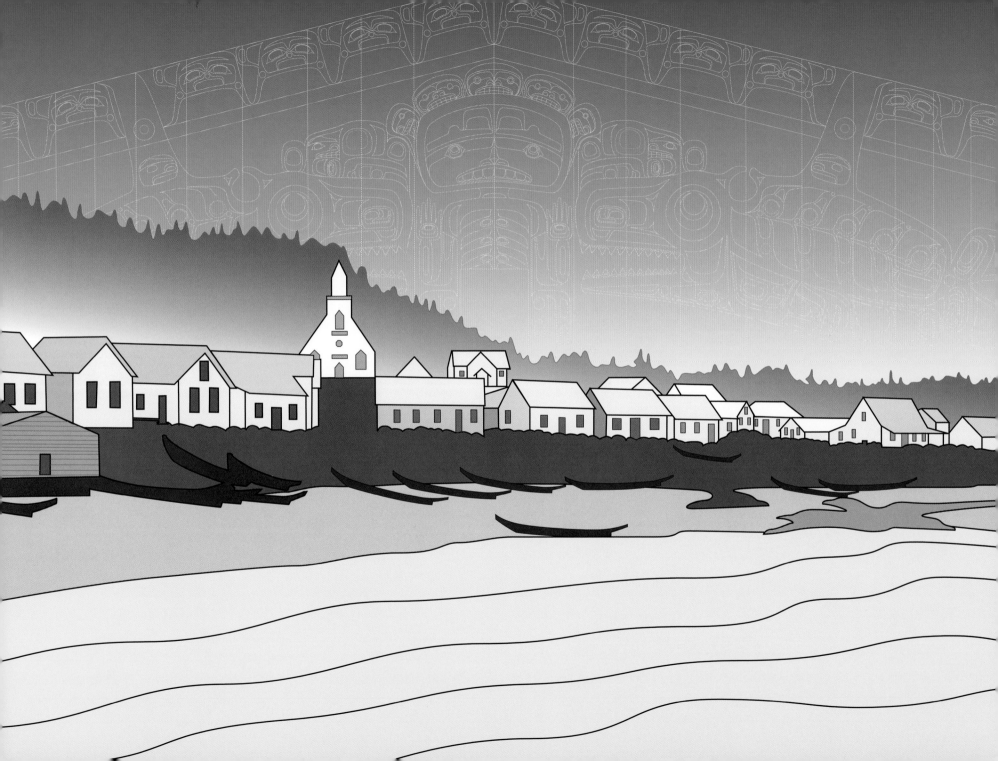

AGNES HARRIS: Robert Cunningham came out from Ireland, sent out for the Church Missionary Society as a lay missionary. He came out from Ireland in the early '60s. Well, he didn't stay very long with them. He joined the Hudson's Bay Company at Fort Simpson.

He was Factor there for some time, and he was a born trader more than a missionary and he thought he would like to make, go into business for himself.

And he looked 'round and found this spot on the Skeena. It was called Spokechute by the Indians.

Opposite: Fort Simpson, called Lax Kw'alaams by the Tsimsien

That estuary was called Port Essington, named by Captain Vancouver for Admiral Essington, of the Royal Navy. And he took that name and put [it] to the place that he founded. He found this was a good spot. And he induced an Indian family to come there, and he said now he was going to have supplies come up. And, of course, they had to come up on the *Otter*, the old Hudson's Bay ship, the only ship going up there at that time.

So he said, "Now, make the captain think there's quite a place here." So they lit bonfires and they put a lot of red bits of red flannel, like flags, up in the trees. And when Mr. Cunningham's first supplies came up, well, it looked as though there was someplace already established, you see. And so that's how he started.

Opposite: The *Otter* Arriving at Port Essington

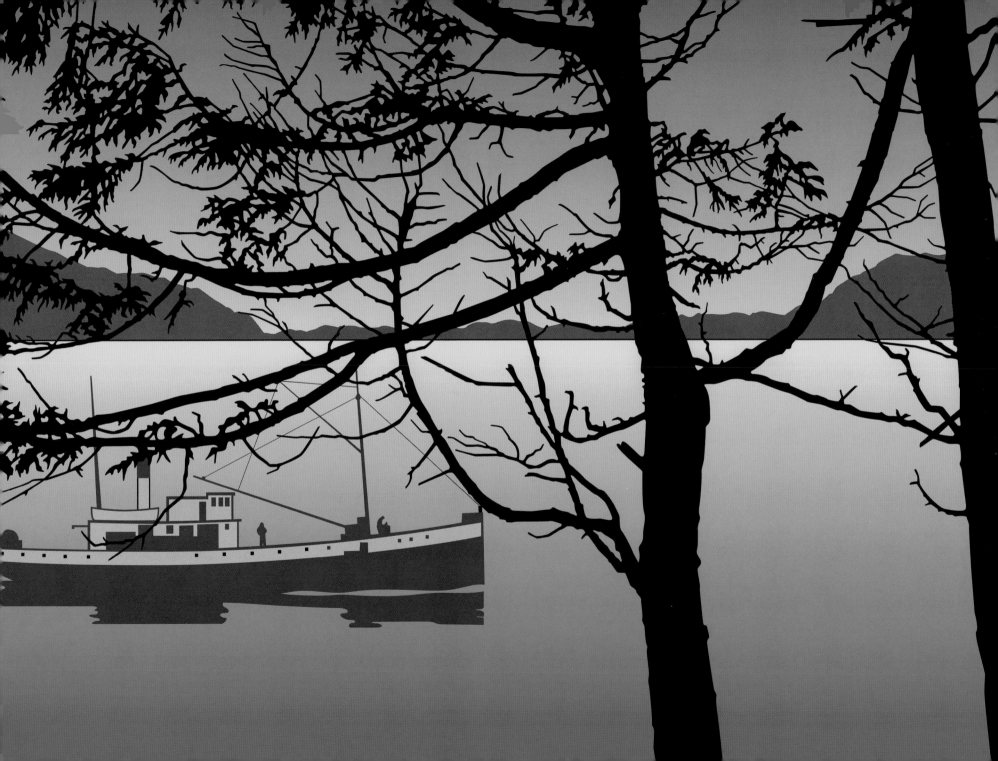

He built a store. That was in 1872. And he built a store and hotel, salmon cannery, sawmill. He had tugboats, and eventually riverboats to go up to Hazelton. Before that, he would help man the canoes to go up to Hazelton to get the furs and so on.

And they had quite a big sawmill. In fact, when Prince Rupert was started, they supplied the lumber for the first wharf, and their piledriver drove the first piles in for the original wharf.

Opposite: Port Essington Rain

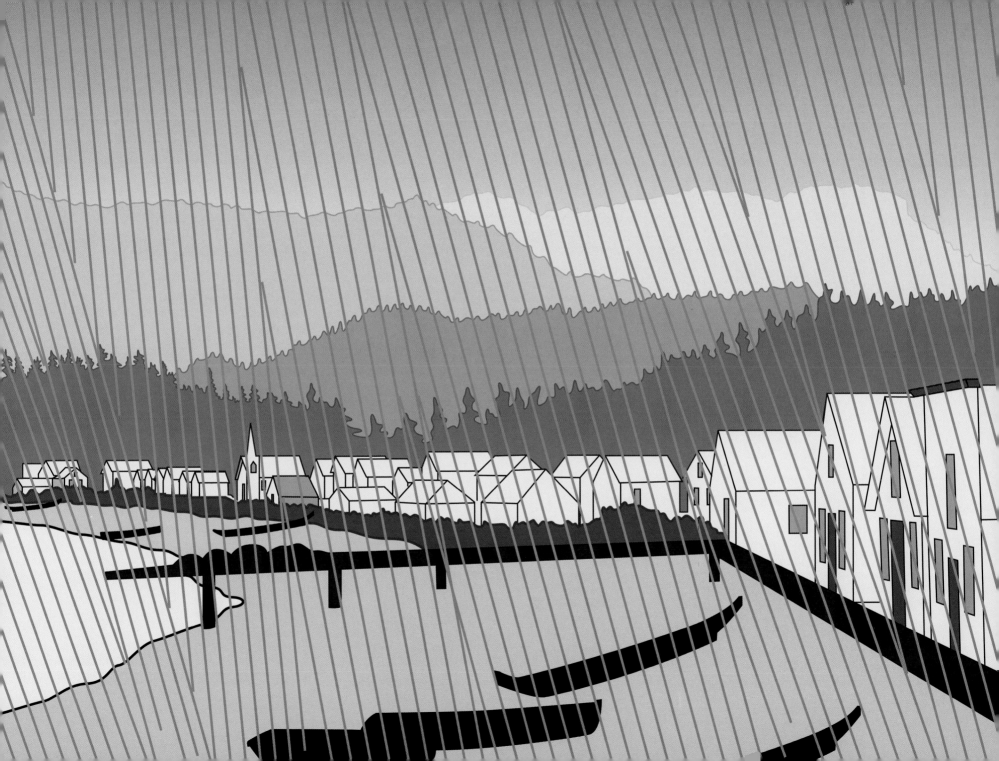

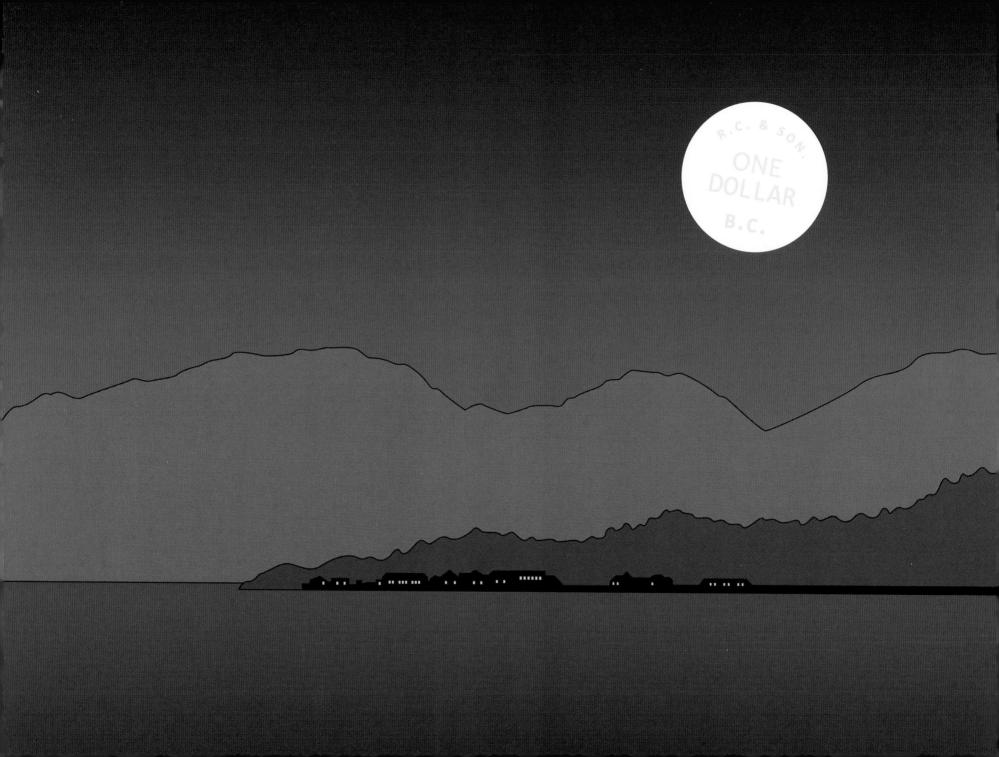

Oh, it was quite a place. The miners would come in, down in the wintertime, and they would stay at Port Essington and they would bring their gold dust, you see.

Well, Robert Cunningham, of course—it was a long way from where there was any bank, and proper coinage wasn't used there for a long time. And so he did the same as the Hudson Bay had done. He got copper and had a die and made the copper coinage—a dollar, fifty cents and quarters—with his own initial on, you see. And that was good for trade in his store.

And he would give that to the Indians for their furs and so on, to be traded back to him for goods. And it all worked out profitably for him and also quite all right for the Indians. They used that for many years.

Opposite: Chickamin Moon

The first, first bank there, I think, was in 1906. Of course, then, they were thinking of bringing the new railway in, but one incident connected with that. When the CPR was being surveyed, they weren't sure whether the Fraser or the Skeena would be the river that would come to the coast. So a survey party went all down the Skeena River to the coast, and they employed Indians as guides and they paid them with paper money, Canadian dollars. The Indians looked at this—it wasn't worth much. It would tear. It was no good. They took it to Mr. Cunningham and wanted his Chickamin [the Chinook word for metal money], as they called it. Of course, he was only too glad to change over. It went back to him in trade too, so everyone was satisfied with that!

THERE'S OLD CATALINE!

—

MARTIN STARRET ON BRITISH COLUMBIA'S MOST FAMOUS
MULE TRAIN PACKER
(RECORDED MARCH 24, 1963)

Jean-Jacques Caux (1830–1922), better known as Cataline, worked as a packer in British Columbia from 1858 until his retirement in 1912, a span of fifty-four years. His knowledge of the Indigenous trade routes meant no settlement was too remote and no mineral exploration site too inaccessible for him to get to, and he never failed to deliver his cargo. His pack trains were a lifeline for large parts of the province, and as a result he became the most famous packer in British Columbia.

Cataline probably got his name, says Roy, because packers were always saying to their animals: "Get in line!" Like all the traders, Cataline spoke Chinook jargon—a mix of English, French, Spanish and other languages—and with his heavy accent it's likely that as he repeatedly admonished his sixty mules to "get in line," it sounded like "cataline." Cataline was easily recognizable in his broad-brimmed sombrero, heavy woollen trousers and riding boots, and he always had a silk handkerchief tied around his neck. Though his reputation was legendary, he himself was very proud of three things: his Catalonian heritage, his Canadian citizenship and the fact that he had, for years, been a friend of Judge Matthew Baillie Begbie. Cataline was in his nineties when he died in 1922. His grave lies under an unmarked cairn in the Gitanmaax cemetery, overlooking Hazelton and the confluence of the Bulkley and Skeena Rivers.

Opposite: Cataline's Grave

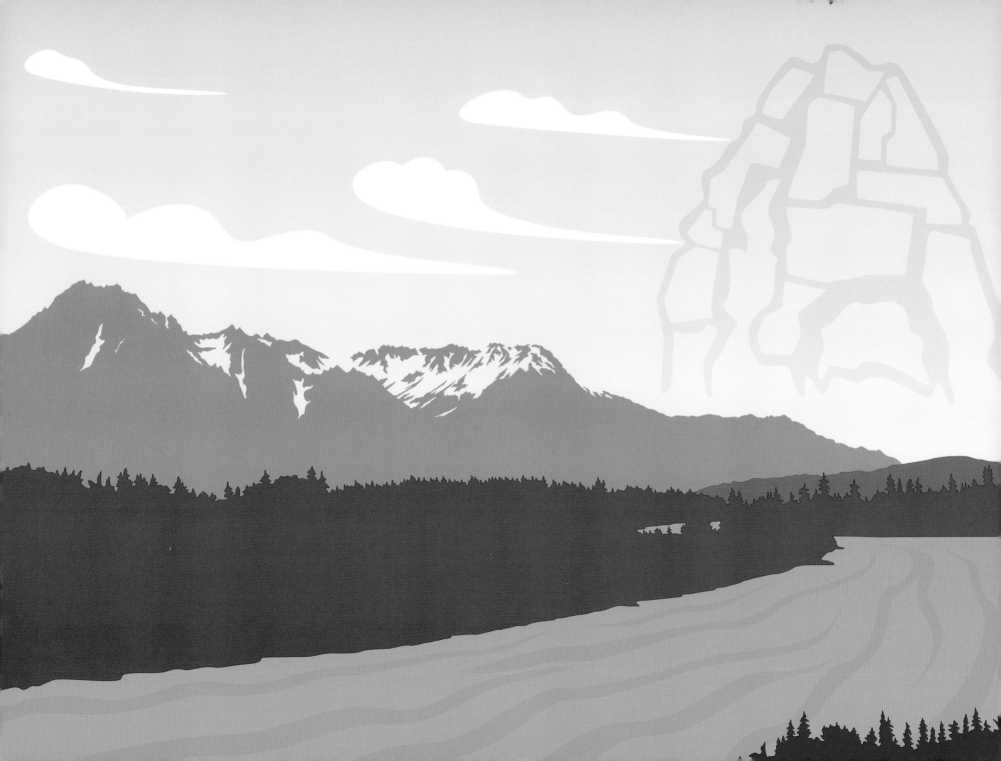

The speaker of the story, Martin Stevens Starret (1888–1973), was born in Hope. He travelled north in 1909 aboard a paddlewheeler to operate a trading post with his mother at the bottom end of Babine Lake. In the 1930s he became an assistant park ranger for the Forest Service at Topley Landing, on the west side of Babine Lake.

Over the course of his life, he got to know many people and places in the area, and he shared over twenty hours of stories about them with Imbert Orchard. Starret Lake in the Babine was named for him, and the Lake Babine First Nation gave him the name Chinnikh, which means "marten" in the local Nadut'en language.

Opposite: Cataline at Hazelton

IMBERT ORCHARD: What do you remember of Cataline?

MARTIN STARRET: Oh, I was too young to drink with Cataline. I'm not a drinking man anyway, but I've seen other fellows. I've seen other fellows there.

And they'd say, "Hey, Cataline! Come on. Have a drink."

"For you for me?"

"Yep. You for me. Sure. You and me."

"All right."

And they said that he'd drink his drink and always leave a little in the bottom, and he'd pour that in his left hand and then wipe it on his head. That was just a curiosity or a fad of his that I don't suppose it did his hair any good, but then he imagined that was a good way.

Opposite: Campfire Stories

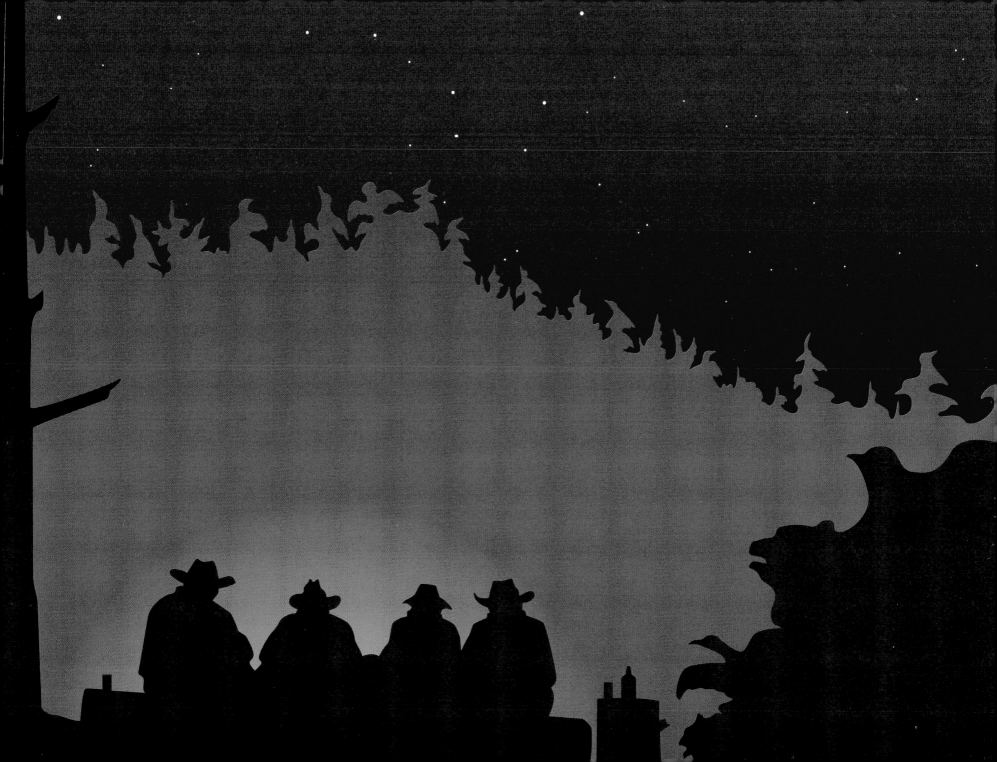

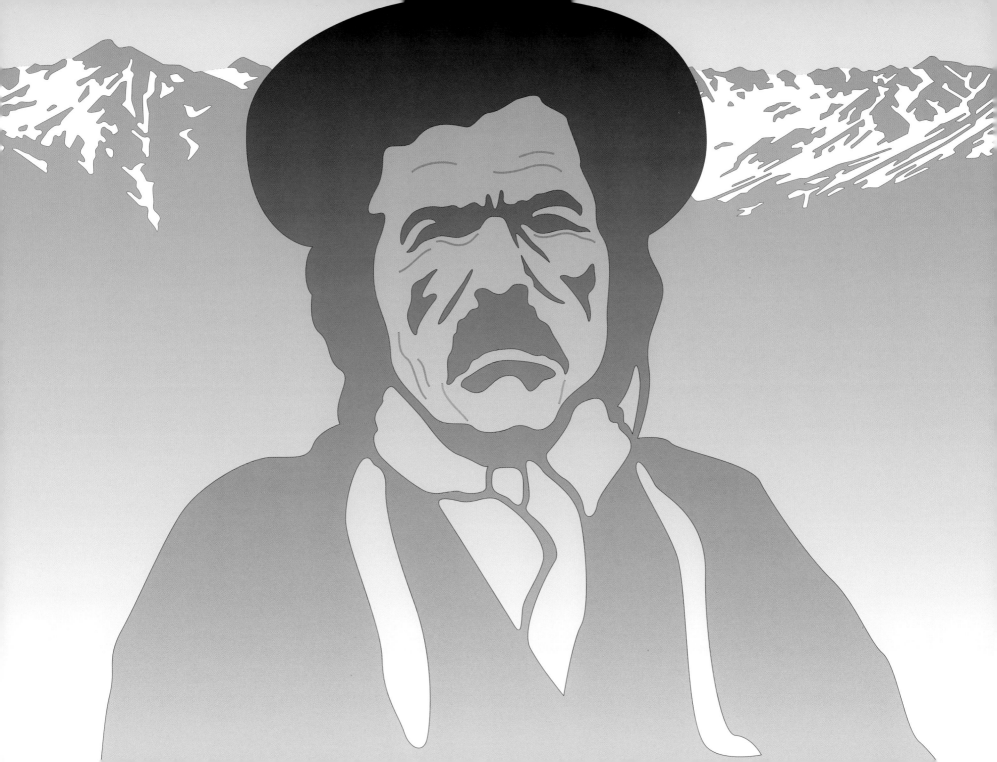

And Cataline wasn't his name. His name was Jean Caux but he used the word "cataline." For instance, he'd have a bunch or a string of horses going along or mules on the trail, and they'd come to a hill and there'd be about ten of them up on this hill, and they'd stop and get their wind when they get out of wind there. They'd all be standing there. Well then, that's holding the whole darn train up.

Cataline'd be sitting back there, and when they think it about time for these mules to start again he'd say, "Hey there! Cataline!"

And then them old mules would flip their ears back and forward and start then, when he'd holler, "Cataline!"

So that's the name he went by.

ORCHARD: Why would he say "cataline"? You don't know, have no idea?

STARRET: Well he was supposed to have been, maybe he was able to say that.

His language was, as Sperry Cline [a constable, and another person that Imbert Orchard interviewed] said, was a jargon: some Chinook and some English and some Spanish, I suppose.

Opposite: Old Cataline's Portrait

I think it was 1910 or '11—it doesn't matter which much—but I was heading down to the Hudson Bay store or warehouse, probably to see about some freight for C.V. Smith, my uncle, the fur trader in Hazelton. I happened to be walking along and I fell in with Cataline. His train was gathered on the street; they took the entire street there, the outfit was right there loading up. Oh I suppose they had sixty head of mules and horses, and probably six, seven packers there. They were just getting the stuff out there. The mules were there, and there was a fellow tinkering with a horse there—with his feet, shoeing the horse. One of these tall Mongolian guys.

And he says, "Hey Tong! You see that, you see that jenny over there, black one. The little one, this side. You take 'em all shoe off that mule. Take 'em all off!"

"You mean you want new shoes?"

"No! Leave 'em off! Two, four case of eggs go Babine, and put 'em one packing eggs, that mule."

And then he turns to me and he says, "No shoe, he go out there and maybe ten miles, fifteen miles, his feet get sore. He walk easy just like a cat and not break one egg! Not break one egg!"

Yeah he shook his finger at me. He made signs with his two hands, "He walk just like the cat," he says. "Not break one egg going down the hill the other side."

He wouldn't go down hard on—not when he get going down the other slope, you know, toward the lake. He couldn't.

I don't suppose he could read or write. He kept everything in his head, his accounts straight as a die. And he came into that country, you know, and brought all that rigging on those animals with him.

Opposite: Cataline's Famous Mule Train

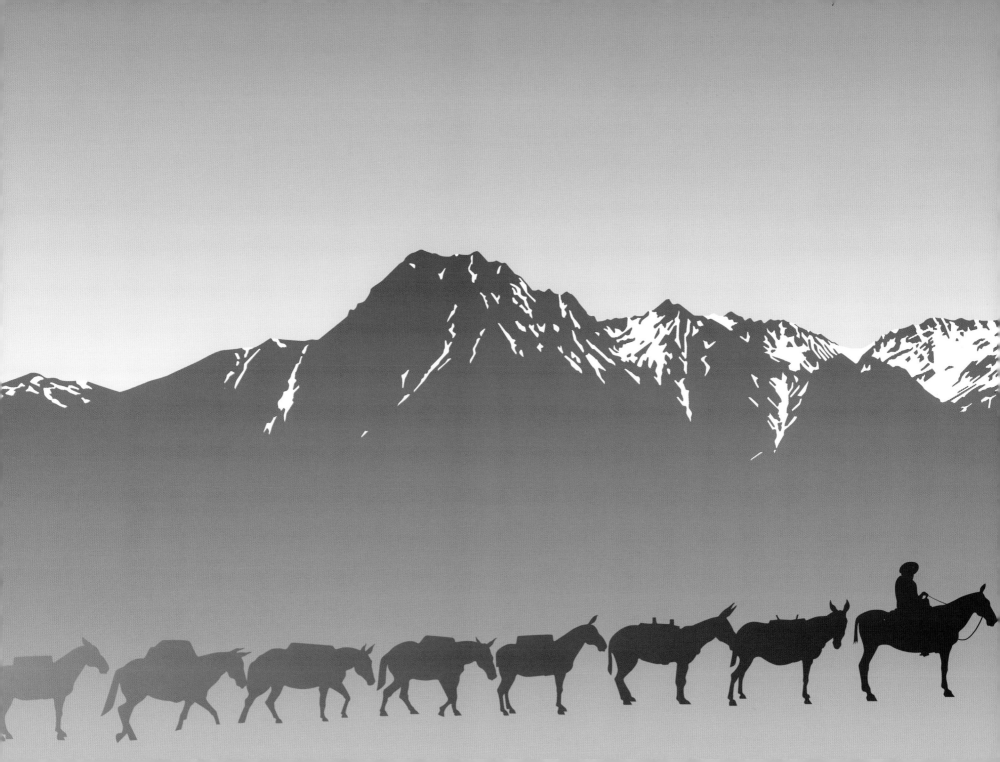

The last time I saw him was in the office of Doctor Wrinch. You know, the Wrinch Memorial Hospital. Doctor Wrinch was a man of about fifty and he'd just been examining me. I had a goitre on my neck, and he kind of pushed me out. And here was Cataline.

"Hey, Cataline! You back again?"

"Yeah, yeah. I sick today."

"Well, you been drinking."

"Oh, just port wine."

"You cut that out. I told you before. Don't you drink port wine or anything else. You can't take it anymore."

"Yeah."

"Well, I can't do anything for you."

"Well, I sick stomach."

"Well, I'll give you something to fix that sick stomach. You keep away from that drinking. I told you before."

The summer of 1917, in August, automobiles were running then. From south Hazelton—there was a bridge right there over to Hazelton in those days—and I was in an auto. And I remember from the direction of Mission Point, toward Hazelton I think it was, on the Hazelton side of the Bulkley River. He was walking toward town very slowly, and I said to somebody in that car (it was an old Model T Ford, you know). I said, "By gosh! There's old Cataline. He must be pretty nearly a hundred years old."

That was August 1917. He only lasted a little while after that. You could see he was old.

Opposite: Cataline Sunset

MONARCH OF ALL I SURVEY

SARAH GLASSEY, THE FIRST WOMAN TO PRE-EMPT LAND
IN BRITISH COLUMBIA
(RECORDED JUNE 28, 1961)

When Lucky first listened to this story while digitizing the Imbert Orchard collection, it instantly became one of his favourites. Sarah Glassey (1881–1962) was the first woman to pre-empt land in British Columbia. She first came to northern British Columbia from Spokane, Washington, at the end of April 1906 to visit her sister and brother-in-law who owned land on the telegraph line outside Hazelton. She left three months later, in August, not thinking she would ever be back because the town and the people there seemed to her to be "wild and woolly!" But Glassey did return in 1910 to visit her sister, and by then Hazelton was booming as work on the Grand Trunk Pacific railroad had brought a rush of construction workers to the area. New roads were being built throughout the Kispiox Valley, and Glassey felt like she fell in love with the country during that visit.

Pre-emption is central to Glassey's story. In 1872, Canada passed the Dominion Lands Act to encourage settlement in the west. The act gave homesteaders the right to acquire 160 acres [sixty-five hectares] of land for free (except for the administration fee) as long as they promised to cultivate at least 40 acres [sixteen hectares] of that land over the next three years. By 1911, women were given the same right as men to pre-empt land, and Glassey did just that, becoming the first woman in British Columbia to do so. Glassey sold her land three years later, after her marriage to Bert Glassey in Hazelton. The story of Sarah Glassey is an example of exactly why oral history collections such as Orchard's are so important: heroes come forth from everyday people.

SARAH GLASSEY: My sister and brother-in-law tried to persuade me to live with them, and I said, "Oh no."

I didn't think that I should do that because two women couldn't live in the same house and get along for any length of time. And I said I didn't think that we could either, any more than any other two women.

And so my brother-in-law said, "Well, I'll give you five acres down on the flat then you can build yourself a house up there."

And I said, "Well, what sense would there be in that? If I was going to come up here and live, why take five acres when I could take a hundred and sixty acres?" You know, take up a pre-emption.

And so he said, "All right. We'll do that. We'll go out and look the country over and you pick out where you want to, if it hasn't already been staked, well, you pick out where you would like a place."

So he saddled the horses, and he and I rode and went all over the country and finally I picked out a place that I thought I would like and we staked it. And when we went into Hazelton, when I was coming out again, we went to the government office to register this.

Opposite: Hazelton Government Office

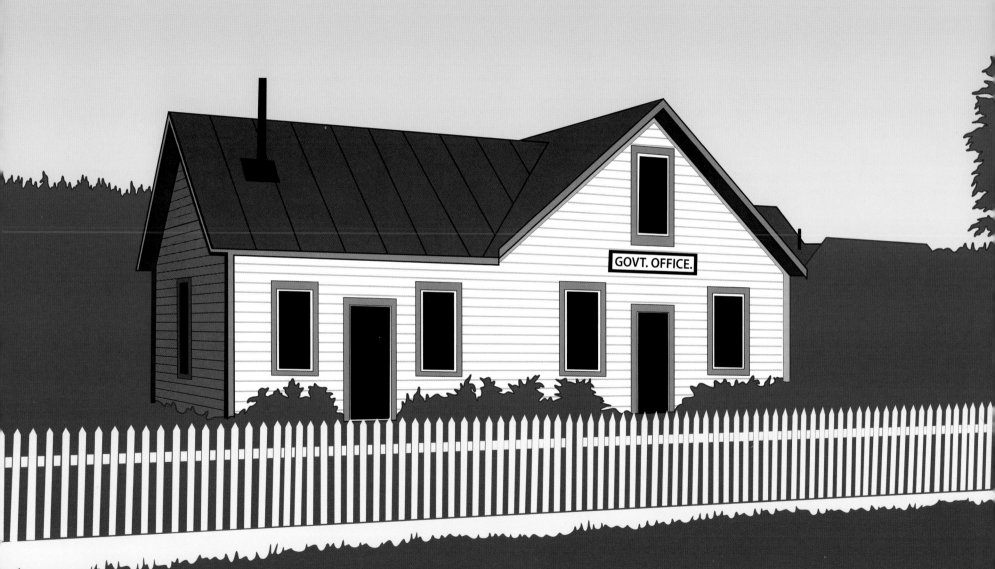

The government agent, who was a Mr. Allison—he was a brother-in-law of [BC Premier] Sir Richard McBride's, and the clerks in the office couldn't believe their ears that a woman was staking a pre-emption. And Mr. Allison told me that I was the first woman in British Columbia, after women got their rights, to do such a thing.

And they thought, Well, we'll never see *her* again, you know—that attitude. But they thought they'd carry on and register me just the same but they certainly never expected to see me again.

That winter I think I was buying every magazine that had any little houses in. So I became quite an architect too, drawing up what I wanted for a house on my place, you know, making measurements and everything.

Much to everyone's surprise, when the first boat arrived in Hazelton I was on board it. And with chickens and all my furniture and household belongings and everything. I had come to be one of them. And they just couldn't believe their eyes. And anyhow, I did. I went up there, and it took over a year before I was able to get a cabin built on my place but I think I'm getting a little ahead of the story.

I have to tell you of our trip up that river that particular time. We came up on the *Inlander*, I think it was, and Captain Bonser, who was notorious, especially for his language, was the captain of that boat. And, when we got to Kitselas Canyon, he ordered all passengers off and especially the women. He didn't want, as he said, a damn woman left on that boat. He said women were bad luck to not only a boat, they were bad luck anyhow. And so we all got off and I think it was two miles, or something like that, from one side of the canyon to the other. So we all hurried up to get around it and watched the boat going through the canyon.

Opposite: The *Inlander* at Kitselas

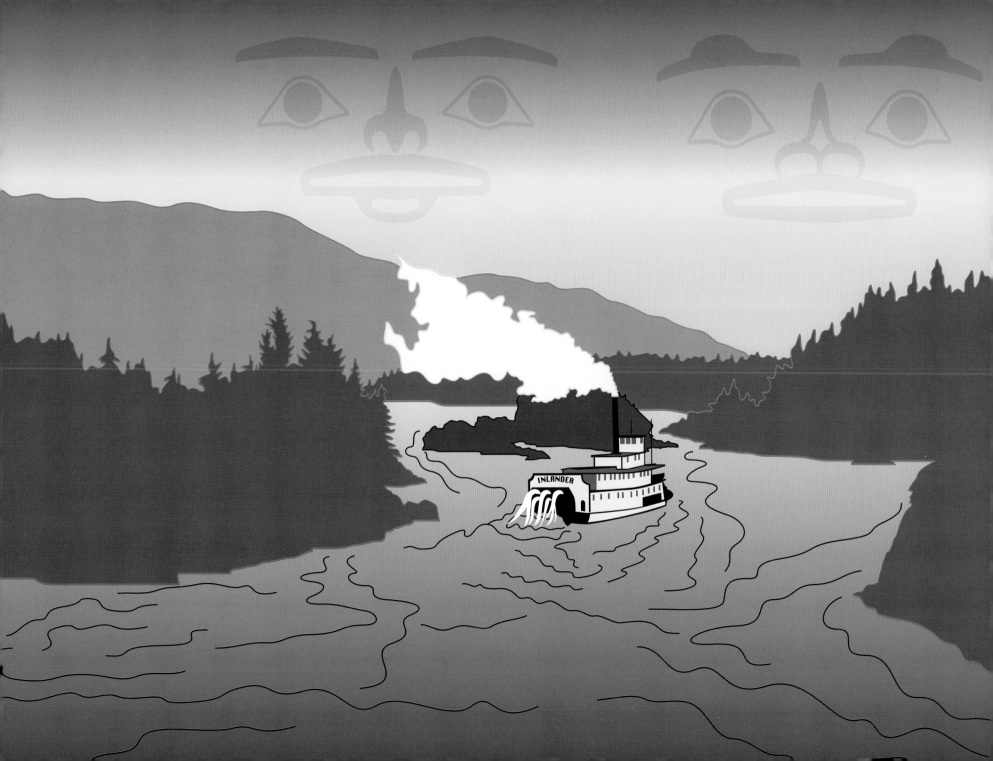

So we were enjoying watching him. Inch by inch it was going on, and they were having to line themselves through and they were making it wonderfully well but slow. And they almost had about one more turn of the paddlewheel to go and they'd be through, when the line broke and away went the boat down through the canyon and down and into the rocks and broke her wheel and she was really battered up.

And he came storming downstairs. Says, "Oh, there must be a woman on board this boat! There *must* be a woman! Look around and check the boat!"

And there they found two women had hid in the freight because they were determined to have the name of having gone through that canyon.

And he said, "I knew it! I knew it! Nothing but a woman would have caused this!"

And these two women came out just looking like two whipped culprits, you know. Oh, they were so frightened. They weren't frightened of the canyon; they were frightened of the captain.

So anyhow, there wasn't anything that could be done about it. They had stayed and he didn't know it and no one else knew it and we hadn't even missed them ourselves. And so they worked all that afternoon and all night to fix the boat, to repair it to go through the trip.

The next day we had our lunch and we were all to get off. This time they were counted. The purser had to stand at the gangplank and count us as we came off, just like so many sheep coming off. I think the two women were quite relieved to be able to get off too, with a whole skin, you know, because the captain was noted to have a pretty bad temper and they didn't know what he was going to do to them.

So anyhow, this time they *did* go through the canyon perfectly. They came right through and we all got on again and went on with our trip up the river.

So, as I say, I arrived in Hazelton, much to everyone's surprise, and went up to the Kispiox Valley and it was a little over a year before I was able to have a cabin built on my pre-emption and got myself established there.

The first night I was over there, my nearest neighbour was a mile away and a river between but, of course, when I moved over the river was frozen over so that wasn't too bad and I could easily go walk over. But the first night I was there I was so happy and I'd look out the window and there was the Babine Mountains in front of me and the northern lights were flashing around. You never saw anything so beautiful.

Following pages: Monarch of All

And the coyotes were howling down on the flat and there was a shriek owl in the tree shrieking its head off and in another tree a hoot owl. *Hoot, hoot! Hoot, hoot!*

And I thought, Go on! Do as you like! You're not frightening me. I'm monarch of all I survey! And I looked over and there were my hundred and sixty acres around me, and me in the middle of it, and I thought I really felt as though I was monarch of all I surveyed.

And I looked out there and looked at the scene of the Babine Mountains and the northern lights and you never saw anything so beautiful as those lights flashing on those mountains and I thought to myself, well, anyone who couldn't believe in God needed to look at a scene like that. And I just bowed my head in thanksgiving that I was part of that country right then. I felt as though I really belonged.

So, things went on for a while and my brother-in-law said to me, he said, "Now the next thing that you have to do is to learn how to shoot."

And I said, "Shoot?" I said, "What am I going to shoot?"

And he said, "Well, you might meet a bear."

And I said, "Well, I hope I do. That is a dream of my life to meet a bear."

And I never did. I never did and I used to walk. They used to tell me that in the fall when the fish were spawning, you know, that the bears used to go along there to pick these fish out. And I would walk miles along the river edge to try and see if I could see a bear right in its natural surroundings but I never did. I think everyone else saw a bear but me. I never did see one.

————

Opposite: Never Saw a Bear

In the meantime, I'd got acquainted with my husband and—who is my husband now, he wasn't then, but I got acquainted with him—and he gave me a .22 rifle. I think that was the first present he ever gave me. I guess he thought I could go and shoot myself or something. But anyhow, he gave me my rifle, so my brother-in-law taught me to shoot and we used to go out hunting together for grouse. So he taught me how to take aim and how he could see grouse and I couldn't see them. And anyhow, he showed me and told me how to find them and everything.

And he had a beautiful Llewellin setter, a thoroughbred, and I had my little fox terrier and we used to take them around. And that Llewellin setter taught that little fox terrier to hunt until it was the best bird dog in the valley, that little fox terrier was.

So anyhow, I got up at three o'clock in the morning. Of course, there's no darkness up there. It was all daylight. So three o'clock in the morning on a Sunday morning, I got up and I thought, Well I'm going out hunting. So I took the little fox terrier with me and we went out hunting. We went up the valley a mile or two and he put up a bunch of grouse.

There must have been about fourteen in the bunch and I got so excited at seeing them that I just stood there petrified, you know, and they flew in all directions until I, I was so bewildered I didn't see where any of them alit in the trees. And I was looking around, looking around in the trees, and finally I saw what I thought was part of a limb sticking out straight with no leaves on and I looked and looked at that and I thought, Is that a grouse or is it a limb? I'm going to shoot at it and just see what happens.

So when I took aim, I was so excited the rifle was just going around in circles, so I had to get down on my knees and I put my elbow on one knee and took aim and shot. And the thing fell down and it was a grouse and it had made its neck so long (they do that so you won't recognize what they are) and it fell down. And my brother-in-law had said, "Whenever you shoot a grouse, when you pick it up, be sure and twist its neck in case it's only wounded," you know, to finish it so it won't suffer.

And I went to pick this up to do just as he'd told me to do and I had shot the head right off of it. Now that was an accident! It wasn't any good shooting and I'm not bragging at all because it never happened again.

———

Opposite: Sarah Sharpshooter

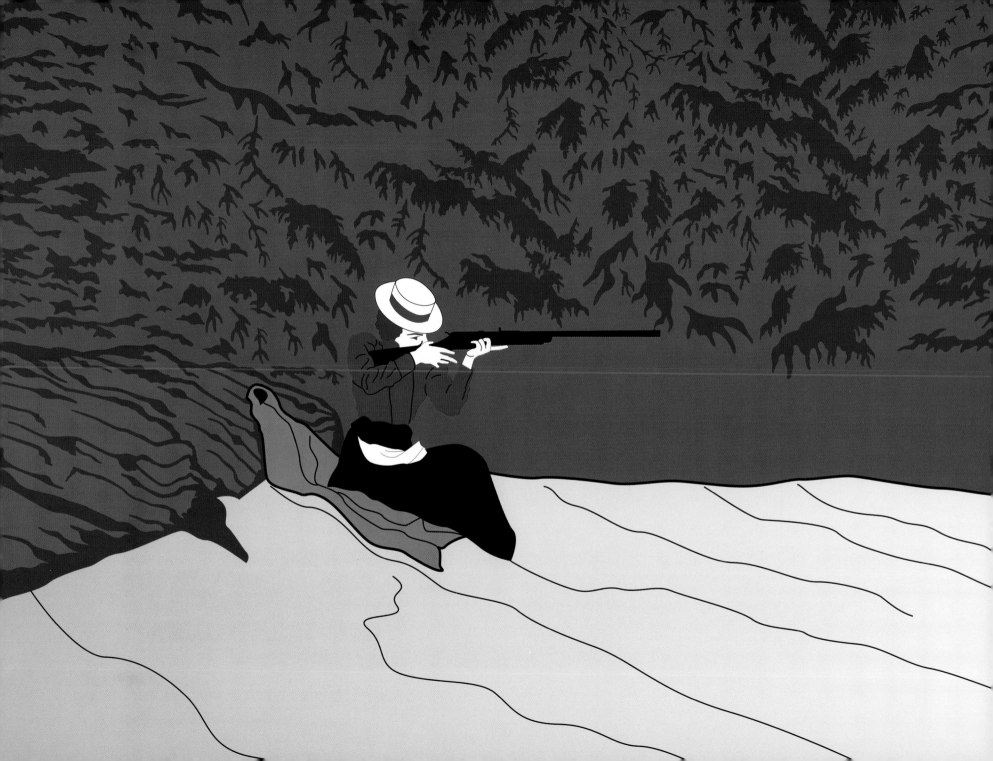

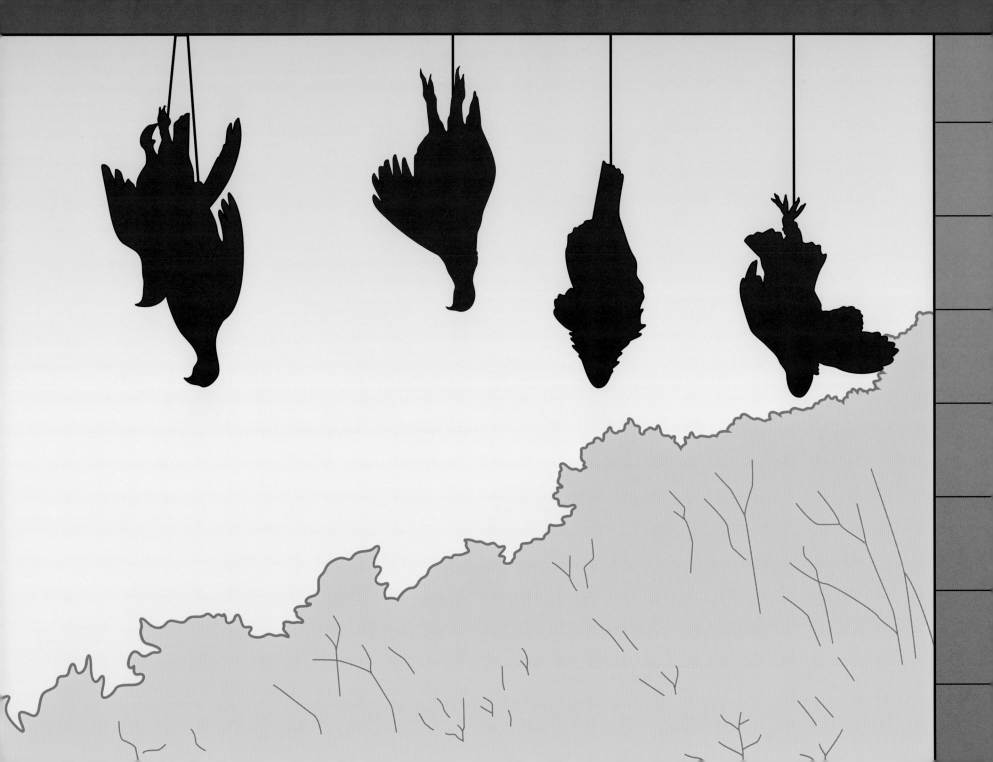

But do you know that I bagged more birds than any man in that valley? And one of the men got jealous of me because I had done that. And, you know, it's not allowed now but pre-emptors were allowed to shoot any time of the year, whether it was in season or out of season for their table, you see. And this man went and reported me to the government agent. The rest of the settlers up there thought that was an awful thing to do to the only woman that had had the courage to come up there.

But every day, winter or summer, I either went out fishing or hunting, but I always took the gun and I always had a line and a hook in my pocket and my pocket knife and I used to cut a limb off of a willow tree and make my fishing rod with that and fish my trout out of the Kispiox.

Honestly, it was the most wonderful life. I lived on that pre-emption alone and my little dog, he finally got killed, and I lived there nearly three years and I don't think I was ever as healthy or as happy in my life as I was when I was up there.

Opposite: Bagged More Birds Than Any Man

You could go out in the woods and pick out any imaginable wild fruit. Your living didn't cost you anything as long as you had flour and sugar and butter. We usen't to buy eggs like you buy them now. They were put up in tins, you know, dry.

You had to do a certain amount of improvement on the place before you could prove up on it, you know. So I happened to announce that I was going to start in clearing land and, of course, that nearly terrified all the men because they thought I was sure going to kill myself by falling a tree on top of myself. So one of them undertook to teach me how to fell trees.

And so he said, "You know, you take your axe and hold it up against the tree and where, if the tree is leaning this way and you put your axe that way, well you chop this way and then it'll fall where you want it to. But if you chop this other way, it's liable to fall on you."

So he taught me how to fell a tree, and one day I chopped down seven trees and limbed them and burnt the limbs and everything and there they were. Much to everyone's amusement when they came and I showed them what I did. I was quite proud of my efforts but they said, well, it looked as though a beaver had been around, so that finished me. I wasn't chopping down any more trees, which I didn't.

Opposite: Sarah Woodswoman

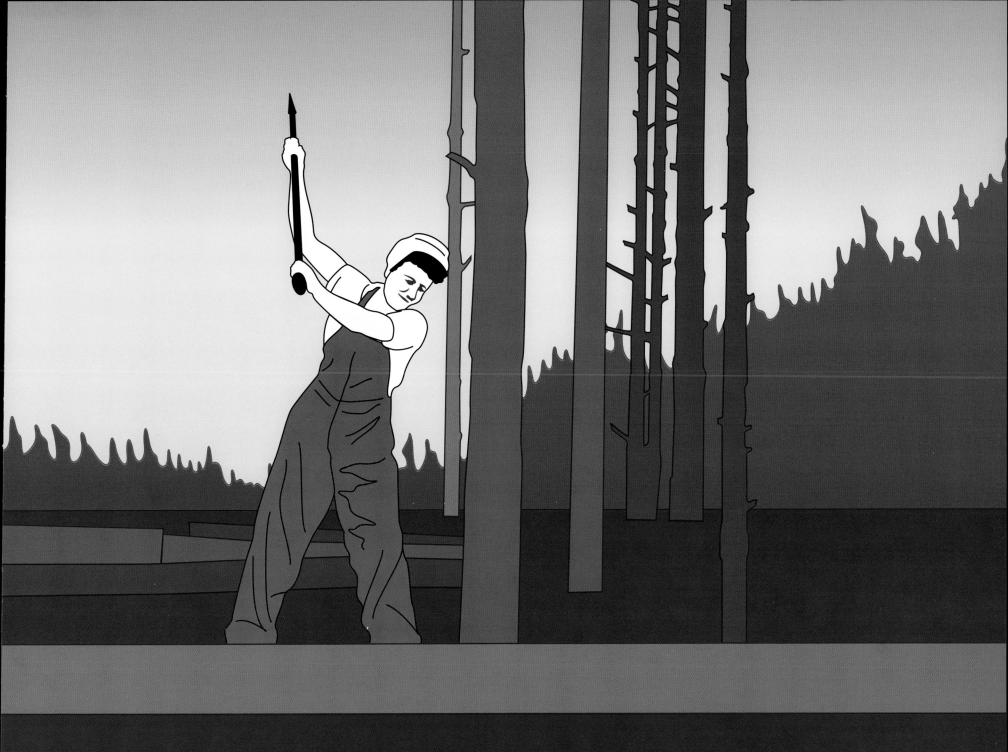

There was an old Indian down in the Kispiox Valley that had his fishing grounds further up in the valley, and I got him to come and clear three acres. All you needed was three acres cleared, so he cleared three acres and the trees that he chopped down he made firewood for me. So I was well supplied with firewood and had all the improvement on my place, but I was told after when the man came to inspect the work that I had done, the house alone would have been all I'd have needed because it was, at that time, the best house that was built in the valley. I had a real nice house. I brought my windows and doors up from Victoria for my house, and they were different to any that was in the country. And it was really wonderful living there though, but going out you were so free and there was a man about a mile further up the valley from me. He had quite a large ranch and he used to go out working but he gave me permission to go help myself to any vegetables I wanted.

ORCHARD: You didn't grow your own vegetables?

GLASSEY: Oh I did, but they weren't like what his were. Mine were little bits of things, you know, because the ground wasn't as cultivated as his was. He had horses that he could cultivate it. Mine was just spade and so, yes, I had a little garden that I could run down and get a few little things out of, you know. And a little fence around it so the horses wouldn't come in.

IT'S JUST ONE BIG BOIL

—

VIROQUA GODFREY ON NAVIGATING THE SKEENA
BY PADDLEWHEELER
(RECORDED FEBRUARY 9, 1962)

Viroqua Godfrey, née Bonser (1884–1977), was the daughter of Captain John Bonser (1855–1913). She was born in Oregon, at a time when her father was the captain of several paddlewheelers based in Portland, from which he served settlements along the Willamette River. She, along with her mother, Ida English (1861–1947), and her brother, Francisco (1883–1894), lived on whichever boat her father was helming at the time. Captain Bonser began designing his own sternwheelers, and he always made sure that living quarters were built so his family could accompany him.

Much of Godfrey's interview with Imbert Orchard is about her father and life on the Skeena River. John Bonser's father and grandfather had been river men on the Ohio and Scioto Rivers, and since he was raised in the culture of river men he knew river travel and navigation at a young age. In 1871, at the age of sixteen, John and one of his brothers, Thomas, left home to seek work on the Lewis and Columbia Rivers. When his brother drowned in 1880, John considered quitting the river trade, but soon after he made a promise to his family to "Never let any river beat me!"

In 1892, Bonser was contacted by Captain George Odin of the Hudson's Bay Company (and also possibly Captain Bell-Irving, as Godfrey suggests; however, this letter has not survived). Odin wanted an experienced captain to navigate the Skeena River route from Port Essington to Hazelton—a journey that was virtually impossible for most paddlewheelers due to the treacherous waters. In his letter, Odin acknowledged: "We understand that you have the reputation of not being afraid to take a steamboat over Niagara Falls, across the Sahara Desert or from hell to breakfast. We've got the boat here and we want a man to take it into the mountains. If you think you can do it, the job is yours."

Bonser took the job and proceeded to build a home for his family in Vancouver. Indeed, Bonser successfully captained more paddlewheel voyages on the Skeena River than any other man, including the very last trip, which left Hazelton on September 13, 1912. He died on December 26, 1913, at the age of fifty-six.

Opposite: SS *Hazelton* at Kitselas

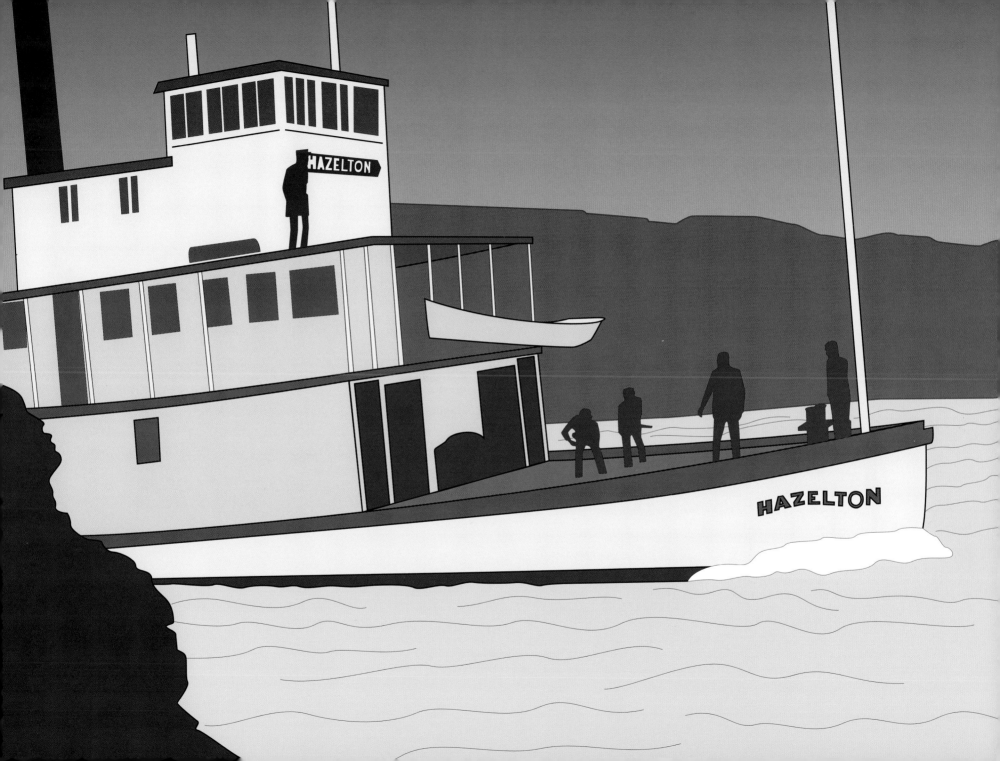

VIROQUA GODFREY: Dad went up in 1891 or 2. He'd steamboated on the Columbia and the Willamette Rivers because it was the middle of the summer like, when they sent for him. Captain Bell-Irving wrote down to Dad in Portland and offered him, what was it, fifteen hundred dollars, I think, for the rest of the season, which was big money then. Well then, that was the first year he went up and then we didn't go up until the next year.

IMBERT ORCHARD: He had a reputation, I suppose, down in there.

GODFREY: No, there would be no cause for a reputation on the Columbia or the Willamette because there was no waters any more [difficult] than just the Fraser River or something like that. You know, the Columbia, they were just small rivers, more like the Coquitlam or something like that, just little rivers and could just be navigated when the water was high.

But he had never had any experience in really swift water. I don't know what he could have thought when he went up there and saw what he had to go through! Don't know really, it's beyond me. How he could just leave a job down there and go up and go on that river and handle those boats. I don't know how he could do it.

Honestly, you have no idea! How that man would stand out on the hurricane deck and give orders to his men on the lower deck! Just a flow of words, and they would follow them. The same in the pilothouse, with the bells to the engine room. He would just stand and he'd pull, and he'd pull, and he'd pull, and he'd pull. Just constantly! And it would take three men—they hadn't the steam gear at that time—it would take three men to move that wheel. To turn it over against the current, against the rudders, you see. It was so strong it would take three men. And the old Indian pilot, old Walter, the perspiration would just pour right down their faces. Honestly, you have no idea what took place in those days. Oh my, the water in those different places: the Devils Elbow and Beaver Dam and the Little Canyon.

Going up the canyon, we would go as far as we can on our own power. Well then, Dad would pull in—of course it's very narrow, as you know—and Dad would pull in to the rock and one of the Indian deckhands would jump ashore. Of course the first few years they didn't have what they call ringbolts that they put in the rocks. They put them in the rocks and then they attach their cable to those, they put the cable through and they fasten that cable in this ringbolt. By this time we have steam. Years before we had nothing but the deckhands on a hand capstan [a winch]: pure brute strength!

Opposite: Ringbolt Island, Kitselas

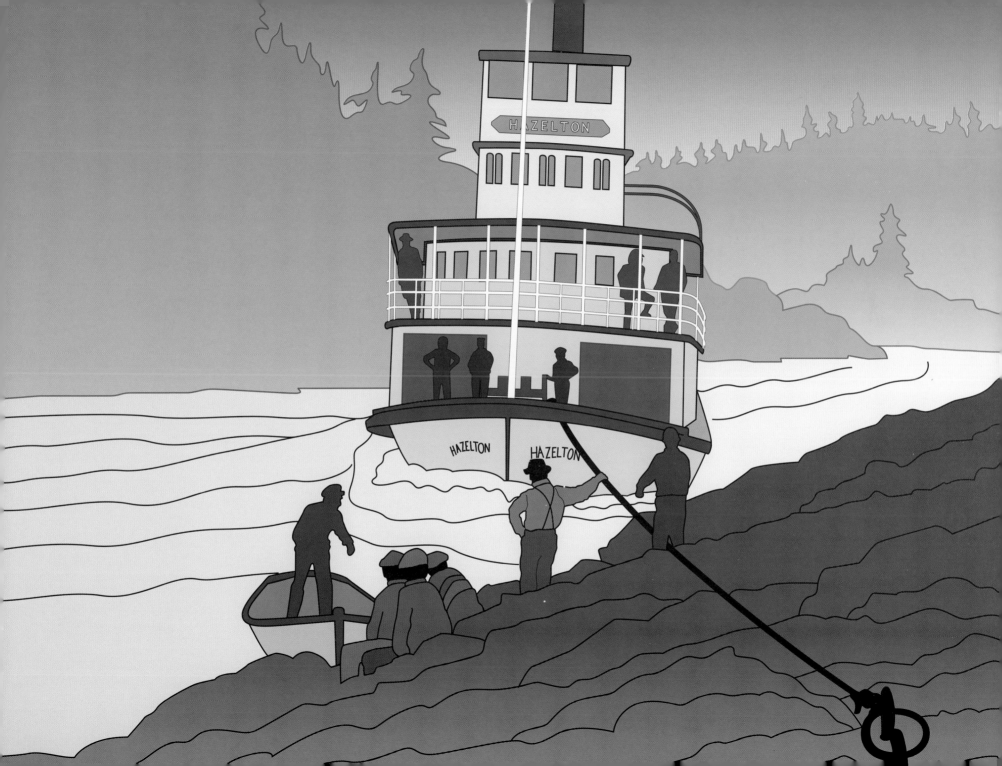

When the boat gets up—this would be at the head of the canyon before we turned this way—when Dad gets the boat up just to where he wants it, he toots the whistle and they pull this toggle out which releases the cable and they bring it in. Then we go on, you see, up the river.

One trip he went up—I think he had the first *Caledonia*, the little boat—and he took my brother with him. The Little Canyon is just one big boil; it comes up and then it goes down and you've got to go through it while this boil is down. Well, I guess he must have got on it when this boil was just coming up and it almost turned the boat over. The mate walked up the side of the boat; it was that far over. And my brother was fortunately in the stateroom and he was sitting on the berth and he just put his feet out. And when she came up, there wasn't a bit of guardrail left on her. That current had just swept that from stem to stern. There wasn't a bit of guardrail on her. That current is so swift.

Oh really! Oh, the times we've had on those boats! Really, I just wonder how Dad ever did it! How he could ever know those swift waters like he did. All the years he was on the river he never lost a man overboard, there was never a man lost on the boats. And at the head of the canyon, of course, is this huge gravel bar. The way that water runs through that canyon! Oh we'd have to wait there for sometimes ten days, two weeks, 'til the water would go down so we could go through the canyon.

We used to climb the mountains and fish. Dad was a great fisherman. It might have been in '93, and we'd get in the lifeboat of the boat. We'd get in there and we'd crawl up on the side that we were tied up on and we'd row up this side and then we'd cut across the foot of the canyon—just boiling, just running down there like a millrace boat—Mother and Dad rowing and we two children in that boat, you know.

Opposite: Setting the Gillnet

And we'd set our net over in an eddy, over across the other side, and then we'd come back. And then go back at night and pull in our net. And one day—one night or morning, I don't know just which—we had rowed over, and Mother and Dad were both rowing and a great big whirlpool opened just at the stern of us. And Dad says, "For godsakes, Mama, pull!" Oh, we were just so near in that whirlpool it would have just taken us down. You know, those whirlpools will just take a great big tree right down. They just suck them right down. They stand right up in the air, just go right down. So I tell you, we were pretty glad to get out of there!

But we had lots of fun on the river. And then we'd go up in the mountains and pick blueberries. And the way we kids used to go around that boat. See I would be about nine, ten years old, and we would just go around that boat like monkeys. No life preservers on, no nothing. Really, the way we'd go around that boat and tear around. It's a wonder that if we ever went overboard it would just be, that would be it. But I guess we were protected some way.

I remember we were up on this other channel, and one morning Dad was saying they were going down on this bar to put a deadman in. 'Course I was very interested in this "dead man." So I said, "Well, can I go along too?"

"Oh yes, you can come along."

So I was all eyes and ears and everything, and I went down. Right down at the end of the bar closest to the canyon they dug a great big hole and they put a great big log in it and a ringbolt in it, and that was the deadman [anchor]! Well, of course, it was quite novel to me.

Dad would run until maybe one or two o'clock in the morning, he'd run the boat. As long as it was daylight. Then when light came again, maybe at four, off we'd be again.

———

Opposite: A Quiet Place

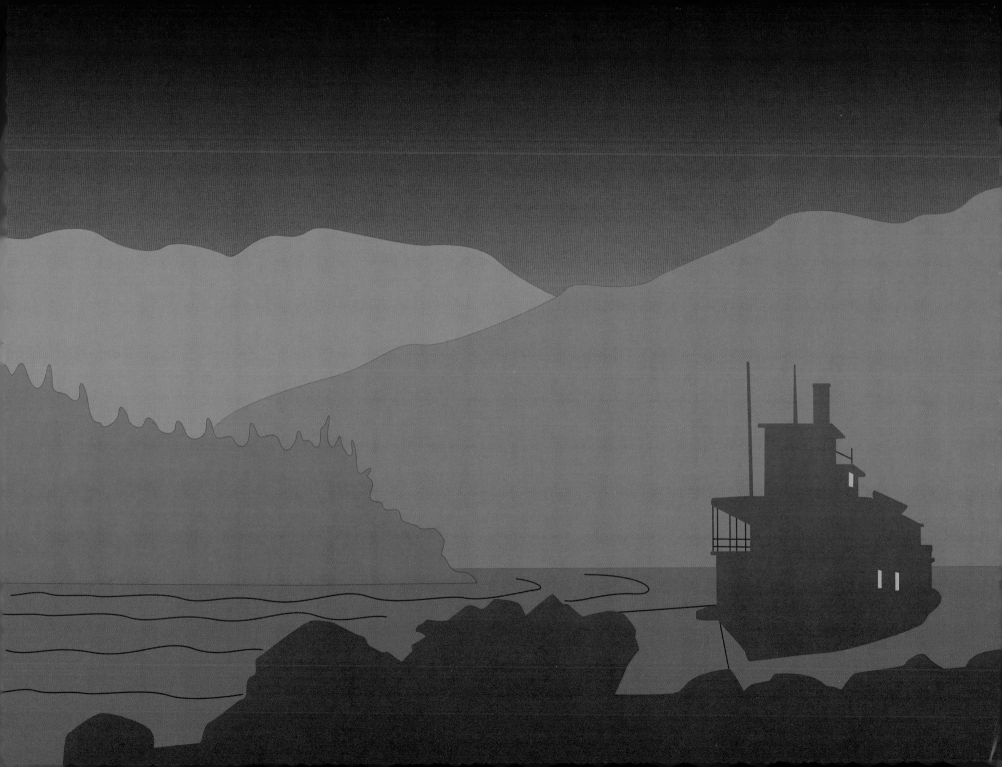

And we'd get to a place, if the water happened to be pretty low, we'd get to a place where we couldn't make it. Then they'd unload all the freight, portage it up a little ways, you see, and then we'd be light enough that we could get over this riffle and load it all on again, and on we'd go.

It starts in May. Well, there is enough water in May. And they might make one trip in May, as near as I can remember. And then they would have to lay up during June because of the freshets: the driftwood coming, so much drift coming down the river. Then they, after June (I just don't know what dates would be), then the river would get down. Why then they'd run pretty regularly until the water goes down in the fall. There might be a little fluctuation of high and low and they might have to wait a few days for the water to come up, you know, or go down. But they then could run pretty regularly until, I guess, in September. 'Cause I knew I never got down to school in Portland in time for school to go in, 'cause I was always … and we went up in May. And I didn't finish my schooling in the spring and I was late starting, and so my education was rather disrupted.

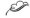

SKEENA, RIVER OF THE CLOUDS

WIGGS O'NEILL, CAPTAIN JOSEPH GARDNER, AGNES JOHNSON,
VIROQUA GODFREY, FLORA MARTIN, MARTIN STARRET AND
CHIEF JEFFREY H. JOHNSON ON
THE WONDERS OF A TRIP UP THE SKEENA
(AIRED 1963)

In 1963, Imbert Orchard was inspired to create a radio documentary called "River of the Clouds" as part of his *Living Memory* radio series that aired on the CBC. He'd interviewed several people separately about the Skeena by that time and decided to splice together bits of those tapes to create a broader picture of life on the river than any single storyteller could provide alone. In producing this tapestry of sound recordings, Orchard drew on interviews with historian Wiggs O'Neill, riverboat captain Joseph Gardner, and local residents Agnes Johnson and Flora Martin as well as Viroqua Godfrey (page 81), Martin Starret (page 49), and Chief Jeffrey H. Johnson (page 13). This excerpt, which is taken from that recording, has been edited by Lucky.

William John "Wiggs" O'Neill (1882-1963) was a fantastic storyteller, and Orchard interviewed him twice in the summer of 1961. O'Neill grew up in Port Simpson (now Lax Kw'alaams) and worked many jobs, the most exciting and important of which was working as a purser on the steamship *Inlander*. He was probably the person in charge of counting all the passengers as they got off the boat in Sarah Glassey's story (page 62). Wiggs became the foremost historian on the sternwheelers of the Skeena River and wrote two books on the subject, *Steamboat Days on the Skeena River* and *Whitewater Men of the Skeena*. O'Neill also co-authored, with Constable Sperry Cline, a book titled *Along The Totem Trail: Port Essington to Hazelton*.

Capt. Joseph Alphonsus Gardner (1880–1966) was born in Mission, BC, the son Charles Alphonsus Gardner (b. 1860), who was the only captain of mixed European and First Nations heritage to navigate the rivers of the Yukon in the 1800s. Following in his father's footsteps, fifteen-year-old Joseph got a job on the *Caledonia*, a ship skippered by Captain Bonser, where he stayed for three years. From there, he continued to work on the rivers and eventually became a sternwheeler captain on the Skeena and Stikine Rivers.

Agnes Kathleen Johnson (b. 1919) grew up steeped in the stories of the Skeena. She was the granddaughter of Irishman Robert Tomlinson (1842–1913), who established a mission for the Church of England opposite the Indigenous community of Minskinisht (MeinSkaniist, "The Bottom of the Mountain") on the Skeena River. Her family remained at the mission after her grandfather died.

Flora Martin (c. 1890) also lived on the banks of the Skeena River, about three miles downriver from Hazelton at a place called McIntosh Landing. There, the sternwheelers stopped to take on the wood that powered them.

This recording mentions the *Mount Royal*, a sternwheeler that was knocked into Ringbolt Island in Kitselas Canyon by strong winds and sank on June 6, 1907. Six crew members died trying to save the boat, but the captain and the passengers survived. The following story takes listeners back in time, to experience the wonders of a more typical trip on the Skeena.

IMBERT ORCHARD: By all accounts a trip up to Hazelton in a sternwheeler was something the passengers were not likely to forget. It wasn't for nothing that the Skeena was considered the toughest navigable river in North America.

The journey began at Port Essington on the south bank of the estuary, and during the summer months Essington got to be quite a bustling little town with its canneries and sawmill, but otherwise it was a very quiet place: a cluster of dreary wooden buildings, hotels, stores, houses and boardwalks squeezed in between the saltchuck [the Chinook word for "ocean"] and the dank wooded hills.

WIGGS O'NEILL: Well, as soon as the captain would toot the whistle, they'd let go, the lines would be thrown off the dock. Two bells would ring, which signalled the engineer to back up, and out we'd go. In backing up on a sternwheeler you had absolute control of your boat, so they'd back up and swing out into the stream 'til they got turned around, and then the signal would be given to go ahead and away we started upriver.

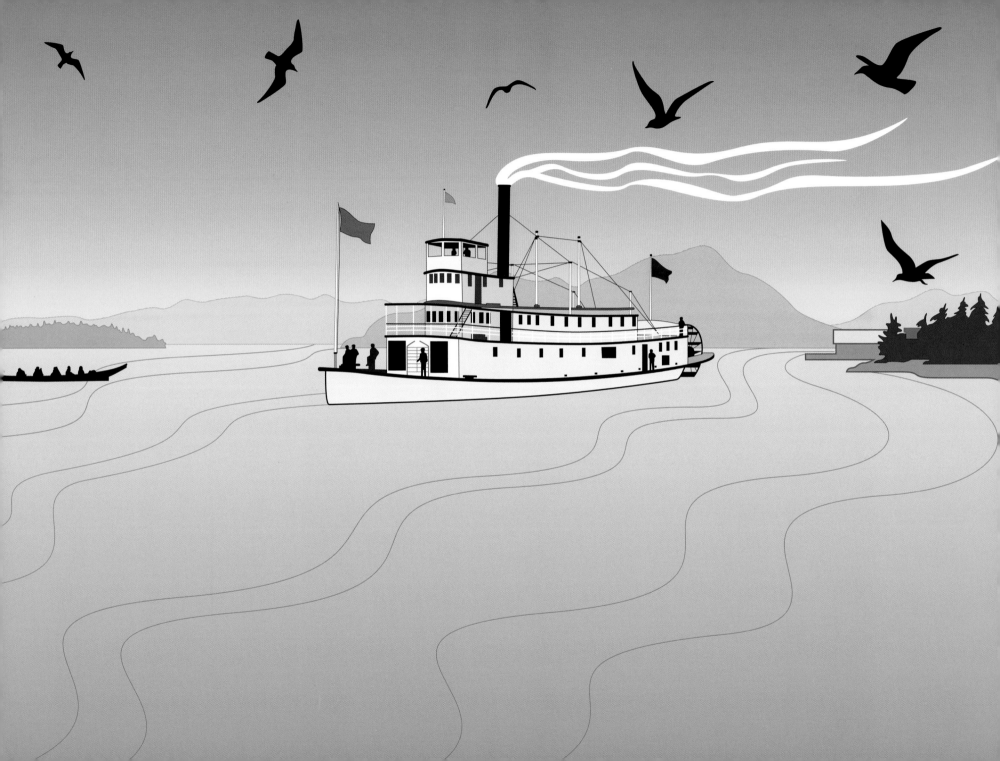

ORCHARD: Now a sternwheeler with her high superstructure and shallow draft was by no means a seagoing ship—all that was left to the sidewheelers—but where the water was swift and shallow, she was unbeatable. She could run her nose up a bank and slip off again like an otter, or heave herself over gravel bars and wriggle round hairpin bends, especially if she did it backwards. Those old-timers used to say she could navigate on morning dew.

CAPTAIN GARDNER: When you left Essington, you took slack water at the bottom and caught the flood tide going up.

O'NEILL: Because when the tide was running ten knots an hour upstream, why, it saves a lot of wood and steam.

GARDNER: You had the effect of that to a place that, even now, they call Hole in the Wall, which is about, oh, around forty miles from Essington. From then on, you lost the tidewater current and you were climbing, climbing, climbing rapids all the time.

O'NEILL: About twenty miles above Port Essington, you'd expect the first woodpile, and if you were getting short you'd go ahead and load up.

GARDNER: In ordinary water you'd burn a cord an hour; that's a lot of wood. And in rapids, two cords an hour.

O'NEILL: In the spring of the year, it was a real picture to see the woodpiles on the Skeena River because, burning two cords an hour, it had to last, you see! There'd sometimes be a hundred, two hundred cords of wood in a pile!

Opposite: Leaving Port Essington

GARDNER: People living along the river, Indians, and everybody else, there happened to be some old prospectors around there, they were given contracts in the winter to cut wood for each company, you see. And they'd haul it out, lots of it with dog teams, you know, and stack it on a riverbank where it's be very handy to a boat, good water. And those fellows got, for delivering that wood onto the bank of the river, it was spruce, birch … they got three dollars a cord. And then when we came along, we, the deckhands, would get out and heave the wood down onto the bow of the boat and it was stacked afterwards.

ORCHARD: When twilight came, the sparks from the funnel shot high into the air like fireworks, and at midsummer they ran perhaps until eleven o'clock before they tied up at the bank beside a woodpile. Then all was still, only the sound of the river slipping by and the mountains encircling them, black as panthers against the starlight.

Opposite: Sparks in the Night

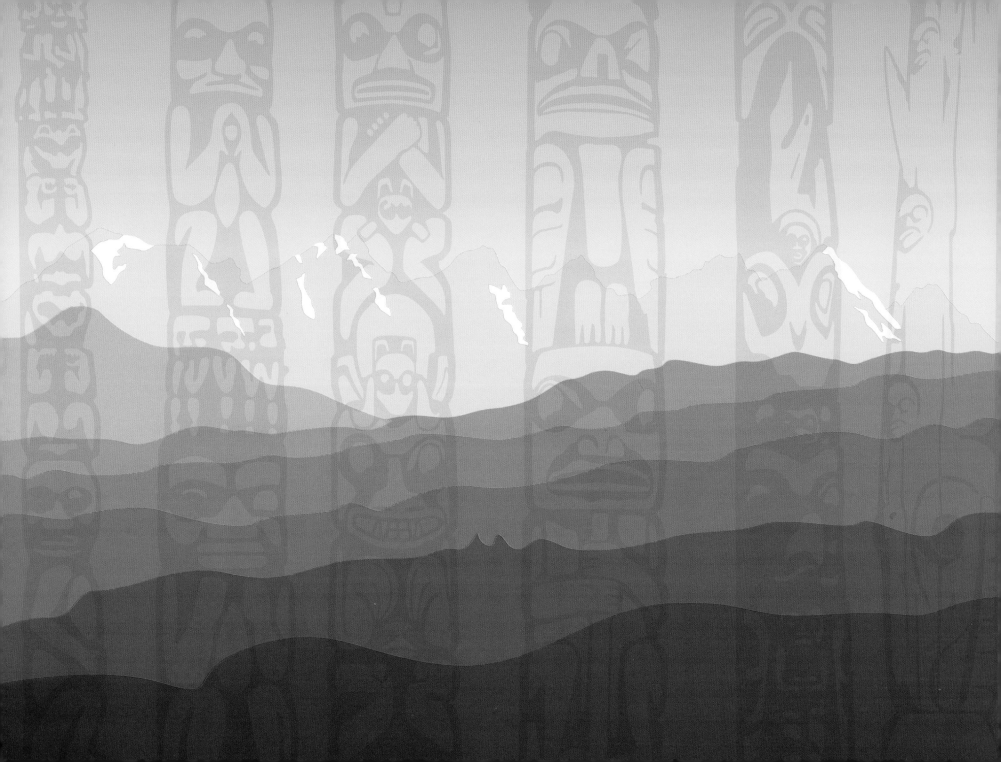

As soon as it began to be daylight, they'd be off again, heading for the canyons. First the Little Canyon, short but tricky, and at GitsumKalum the mountains roll away, and the sky opens and closes again at Kitselas. The Big Canyon: Kitselas. Halfway to Hazelton, Kitselas divides Upper from Lower; dry country from wet. Kitselas guards. There was a time when no one passed up or down without leave of the chiefs of Kitselas. Their longhouses lined the canyon and their totem poles were the banners of their authority. Belonging neither upriver nor down, they owed no man allegiance but kept the peace, until the white man came.

Opposite: Totems, Banners of Authority

There were times when the water was too high or too low and no one passed. Then they'd tie up at the white man's village at the foot of the canyon and wait there for hours—days sometimes—fishing, drinking, playing horseshoe or just watching the water gauge.

GARDNER: I remember one day going up; there were no other boats would look at it except old Bonser. And he gives a holler out of him just at daylight. He says, "We're going through that canyon today, but every passenger get off." So they all trooped ashore so they could walk over the portage, you see, the wagon road.

ORCHARD: And while the passengers took to the trail, up the hill and through the woods and down to the landing at the other end, the crew would take her through, heading her nose into the swirl and roar of the waters.

GARDNER: We just went from side to side, bouncing on these great big boils—not whirlpools but big boils—and there's a ringbolt in the rocks at the top of it, you see. We got up to this Ringbolt Island and these Indians—they were all Indian deckhands, the white man couldn't stick it. Going down the canyon at highwater was worse than coming up, you know, 'cause you had to go through just like lightning.

ORCHARD: In the upper country, the mountains were not so sheer and high against the river and the growth was smaller, drier, with maple and birch and aspen as well as cedar. The sun shone more brightly but humans used to be just as scarce. Here and there would be railway camps, and a few old characters were still placer mining at Lorne Creek: relics of a gold rush in the '80s. Then came Minskinisht, Reverend Robert Tomlinson's Indian mission. Today it's known as Cedarvale. In those days, there was a small log church down by the riverbank and attractive-looking homes with nice little gardens.

Opposite: Memories of the Holy City

AGNES JOHNSON: They were all working out on the garden one day, and they heard what they thought was a blue grouse drumming. I guess you know how the blue grouse drum, they go *whum, whum, whum,* and they heard this *whum, whum, whum* and it would stop. Then they'd hear again—*whum, whum, whum.* And this kept up for a couple of hours. Finally someone said, "That's not a blue grouse," and somebody said, "No, what is it then?" and they started to listen. Then they heard the sound coming quite distinctly, and somebody said "Oh, that's that steamboat they've been talking about." They dropped their hoes and they dropped their rakes and they made a dash across. There's an old snake fence over in the bush there, and over the fence and down on the riverbank and they were hollering and whooping and yelling. And the steamboat came up the river here and they started blowing their whistle and ringing the bell. The people were up on deck and they were hollering and yelling and shouting back at them and what language they spoke didn't make any difference, they were all hollering and yelling. They landed up in front of the village there.

ORCHARD: That was in the spring of the year 1891. The steamboat was the *Caledonia* with Captain George Odin of New Westminster.

Opposite: The *Caledonia*

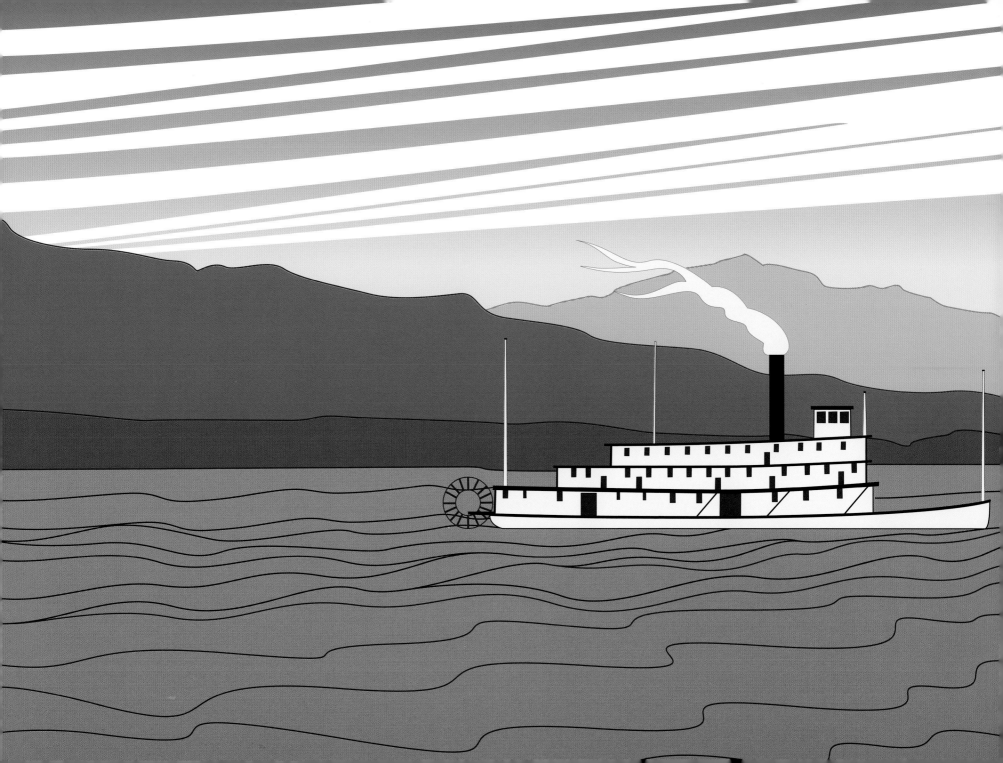

JOHNSON: My grandfather [Rev. Robert Tomlinson] told them that they could not pick up cordwood on Sundays; they could not stop here on Sundays. They must go right through. He told them they could throw the mailbags off on the other side of the river. And there they laid 'til Monday morning when somebody went across to get them. But they couldn't have the bags on this side of the river. And the people tabbed it as a holy city. The other people, you know the steamboat captains and so on.

One thing that happened while the steamboats were coming up, they still were using the little log church down by the riverbank, and they had been taught—my grandfather and others had taught them—to sing. And they must have had a very good choir because one Sunday evening the steamboat was coming down the river and the captain slowed down so that there was hardly any noise from the engine or the paddlewheel for the passengers on board to stop and listen to the people singing, because they were singing so nicely.

ORCHARD: After Minskinisht came the Indian villages of Kitwanga [Gitwangax] and Gitsegeukla. And somewhere on the upper river, the steamboat would tie up for the second night. That is, if the going had been no more than normally tough or the water neither too high nor too low. Sometimes it took days to get up, and the closer they got to the end, the more obstacles the old river threw in their way: rocks and riffles and whirlpools and—

O'NEILL: Beaver Dam and the Whirly Gig. When you go in to the Whirly Gig, the steamer and feeder going this way and that way. Great big boulders, and they ran across the river like a dam, you see, only there was a passage between two of them just about wide enough to get through. And the captain was coming up why he had to strike that passage right on the nose. You see, and go through between these two boulders.

GARDNER: The greatest rivalry, I think, was between Captain Johnson and Captain Bonser. These skippers would steal one another's wood, you know; they'd get racing and be running out of wood and come to a nice big woodpile and the skipper would holler down, "Come on, you passengers, everyone get out there and throw wood aboard this boat." And they'd all go out and they'd heave it down, you know, and before the other boat could get at them or she was getting close, out they'd go and the passengers would get wildly excited when they're racing.

VIROQUA GODFREY: Dad [Captain Bonser] was such an opposition man he always wanted to race, you know; he wanted to be first. And it was the same when he was on the Columbia River and the Willamette River; if he could get a boat to race with, he would just race and then they'd put the broom up on the flagpole in front of the boat, you see, that you've won this race.

GARDNER: Captain Johnson got ahead of him one day near a sandbar, you see. Bonser had stopped to get wood on and he hadn't quite finished when the *Mount Royal* came along and went ahead of him. And Captain Johnson hit a tough piece of water, what we called riffles—we never called them rapids—and Bonser caught up to him and shoved his stern right up onto a sandbar, you see, wheel and rudders and everything and then went by him. It was an awful thing to do, you know, he might have torn those rudders right off. And that's when poor old Johnson, you know, grabbed a rifle and his wife was aboard and she stopped him; he was ready to shoot, yeah.

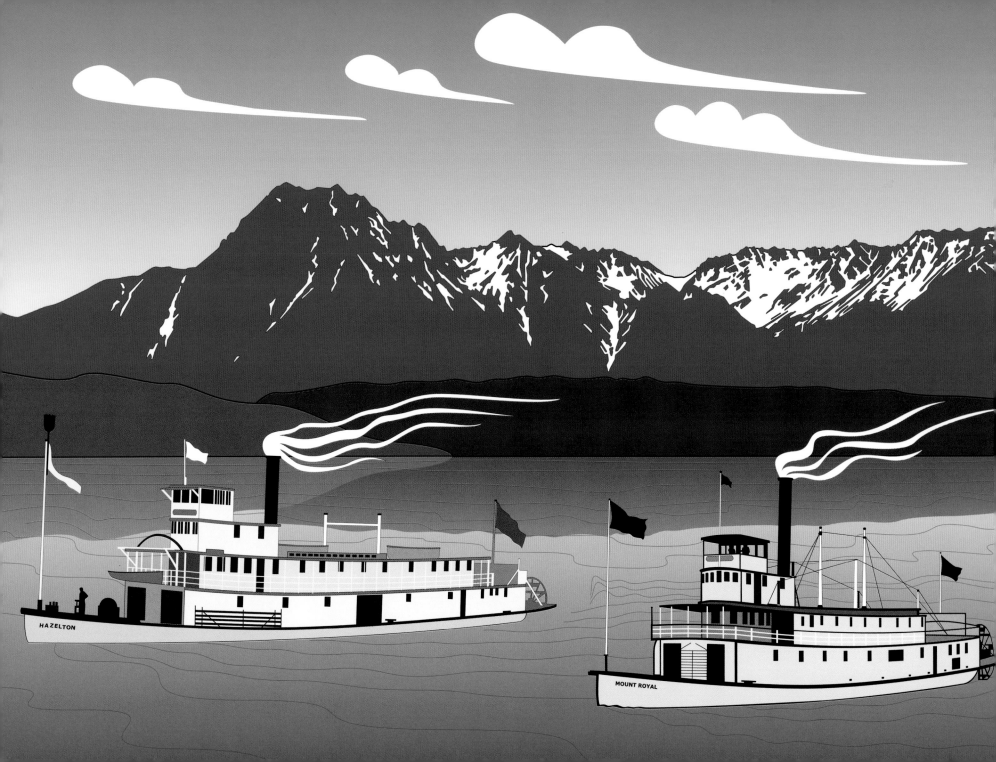

GODFREY: It was just a rivalry as to who would get there first and swearing at each other from the pilothouse to pilothouse and each calling the other one names.

GARDNER: Then, you see, if you came into Hazelton first, especially in the spring, and you had a broom at your masthead, you'd swept the river clean. And then there's that great mountain Rocher Déboulé, you know, that sets the whole scenery off; it's a wonderful mountain land. And across the river there are big benches of flat land and then more mountains up behind them. And below Hazelton it's covered with these big Balm of Gilead trees—beautiful sight.

O'NEILL: Well the first boat that was to arrive at Hazelton, the story was told when she blew her whistle down the river, which was never heard before, the old Indians hid for the hills—they thought the devil was on their track. The people living on the river, they would hear the sternwheeler coming if she was coming upstream, you know. They'd hear sometimes for an hour before it ever got there; that sound was caused by escaping steam, you see. When the valve opened and the exhausted steam shot into the funnel, that's what made the noise.

GARDNER: The exhaust was mixed with the smoke so it looked white; it looked white most of the time.

O'NEILL: And believe me, it was a sight to see a sternwheeler steaming up tough rapids and wide open; it was just belching with steam and smoke out of that smokestack, no man's business.

GARDNER: Kids used to get up on the big bench behind the town there, and you could look down toward what they called McIntosh Bar, about eight miles away. You couldn't see the boat but you could see her exhaust coming up above the hilltops. And then they'd all start shouting, "Steamboat! Steamboat!" They'd start shouting right at the top of the hill and come running down.

FLORA MARTIN: And we'd listen. Sure enough we'd hear the puff and we could hear it go miles down. Everybody, the whole town, would get into their coats and fly down to the wharf, you know, to see the boat come in.

———

Opposite: The Race Is On

O'NEILL: The captain always blew the whistle at a big cottonwood tree down at the riverbank just opposite Hazelton.

MARTIN: And I was so deathly frightened of that whistling because it was so, so loud and shrill, you know. I'd just wait in agony 'til it did blow.

MARTIN STARRET: Oh my, the steamboat would whistle and the dogs would hooooowl and there'd be about, well, not a thousand of them but you'd think there were ten thousand of them to hear them holler. It seems the whistle affected their ears, or tickled their ears. Then they'd all be down there, every man in the town, even if it was just before time to open the bank the man would be down there. I don't know, maybe he'd lock up and be down there anyway because there's nothing going on when the steamboat would land. They'd be lined up there and they'd get the gangplank out and these fellows would walk ashore.

ORCHARD: And then the passengers all went about their business somewhere in that North Country while the sternwheeler quickly got rid of its freight to the stores and the waiting pack trains and headed down the river for another cargo. The season was short, and time itself was running out: the railway was on its way.

In the summer of 1912 Captain Bonser took the last of the sternwheelers—the *Inlander*—down the river. She was hauled up on the ways at Essington and left to rot, like other things and places born of the fur trade and the old placer mining.

The railway built new towns and cities, and brought in a new kind of people to live in them; people who were strangers to the river, who had never waited for tides and winds and seasons. They had no memories of towlines and riffles. They had not faced the guardians of Kitselas, like the people of the river coming and going on cloudwaters.

CHIEF JOHNSON: Active, strong people. I don't see any, any young men today like those people in those days. I don't know why.

Opposite: The End of an Era

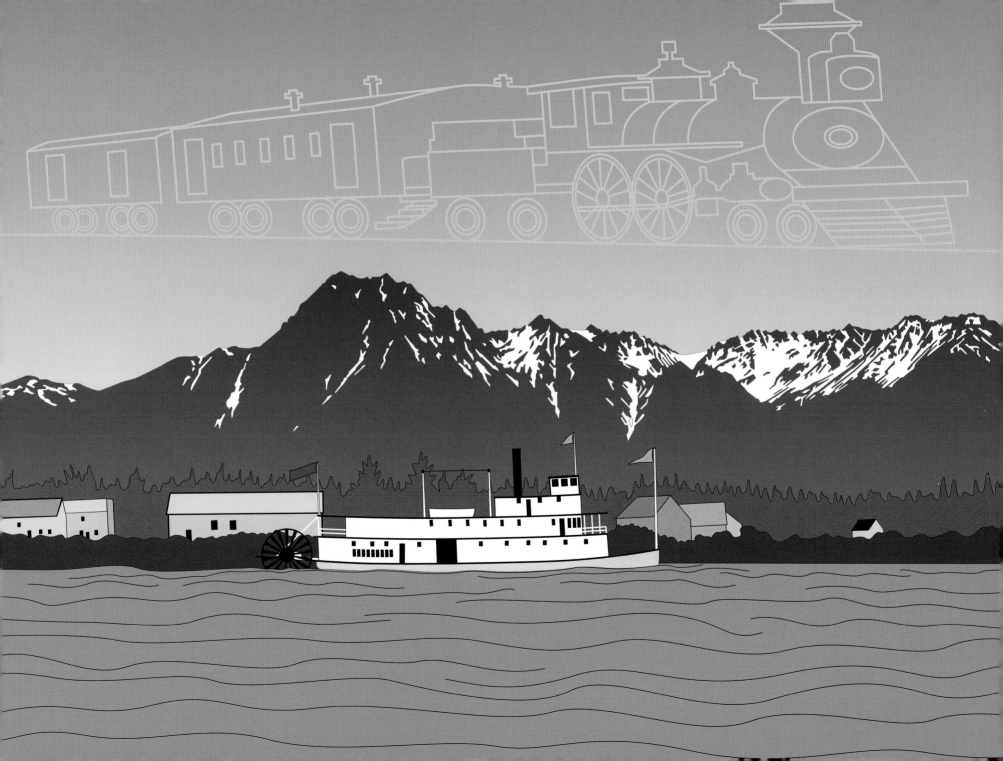

TRADITIONAL PLACE NAMES

Much traditional knowledge has been lost, even among the Elders. Stories are one way to pass on the language and other knowledge. Roy says, "The ancient words cannot be spelled accurately using the English alphabet, so I use phonetics to come as close to the sounds as I can. Sometimes it's not possible." Various spellings exist, often because when interpreters use the ancient language, the pronunciation is incorrect and the resulting spellings are misleading.

Anspayawks (Kispiox): The name of this village is interpreted as "The Hiding Place."

Gitanmaax: Hazelton is situated on the Gitanmaax Reserve, whose people are known as Torchlight Fishermen.

Gitsegeukla (Skeena Crossing): Long before the Canadian National Railway crossed the Skeena River, the village at this site was known as Gitsegeukla, "People of the Segeukla River." A legend tells us of a woman who was frozen in fear near the headwaters of the Segeukla River.

GitsumKalum: The meaning of this word is "People of the Kalum River."

Gitwangax: The meaning of this word is "People of the Place Where There Are Rabbits."

Kitselas: The Big Canyon is known to Indigenous people as "People of the Waterfalls."

Lax Kw'alaams (Fort Simpson, Port Simpson): The traditional Indigenous name for this town is interpreted as "On the Place of Wild Roses" and is in common use today.

MeinSkaniist (Cedarvale) translates to "The Bottom of the Mountain."

Spokechute (Port Essington): To this day, Indigenous people use the name Spokechute, which is interpreted from the Tsimsien language as "Autumn Camping Place."

Stegyawden: The Rocher Déboulé mountain at Hazelton has been known to Indigenous people as Stegyawden for thousands of years, though the meaning of this word has now been lost.

✍ Visit **http://memoriestomemoirs.ca/skeena** to hear Roy pronounce these names, as well as listen to an additional interview: Walter Washburn on the wreck of the *Mount Royal* on July 6, 1907.

Opposite: Kitselas

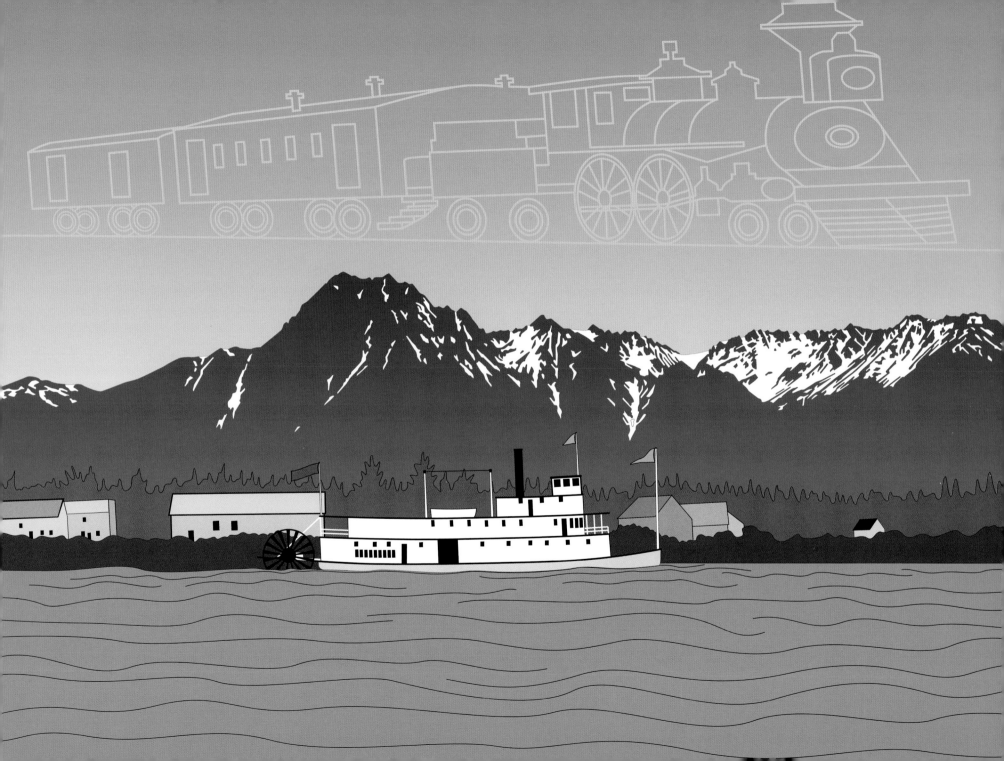

TRADITIONAL PLACE NAMES

Much traditional knowledge has been lost, even among the Elders. Stories are one way to pass on the language and other knowledge. Roy says, "The ancient words cannot be spelled accurately using the English alphabet, so I use phonetics to come as close to the sounds as I can. Sometimes it's not possible." Various spellings exist, often because when interpreters use the ancient language, the pronunciation is incorrect and the resulting spellings are misleading.

Anspayawks (Kispiox): The name of this village is interpreted as "The Hiding Place."

Gitanmaax: Hazelton is situated on the Gitanmaax Reserve, whose people are known as Torchlight Fishermen.

Gitsegeukla (Skeena Crossing): Long before the Canadian National Railway crossed the Skeena River, the village at this site was known as Gitsegeukla, "People of the Segeukla River." A legend tells us of a woman who was frozen in fear near the headwaters of the Segeukla River.

GitsumKalum: The meaning of this word is "People of the Kalum River."

Gitwangax: The meaning of this word is "People of the Place Where There Are Rabbits."

Kitselas: The Big Canyon is known to Indigenous people as "People of the Waterfalls."

Lax Kw'alaams (Fort Simpson, Port Simpson): The traditional Indigenous name for this town is interpreted as "On the Place of Wild Roses" and is in common use today.

MeinSkaniist (Cedarvale) translates to "The Bottom of the Mountain."

Spokechute (Port Essington): To this day, Indigenous people use the name Spokechute, which is interpreted from the Tsimsien language as "Autumn Camping Place."

Stegyawden: The Rocher Déboulé mountain at Hazelton has been known to Indigenous people as Stegyawden for thousands of years, though the meaning of this word has now been lost.

✏ Visit **http://memoriestomemoirs.ca/skeena** to hear Roy pronounce these names, as well as listen to an additional interview: Walter Washburn on the wreck of the *Mount Royal* on July 6, 1907.

Opposite: Kitselas

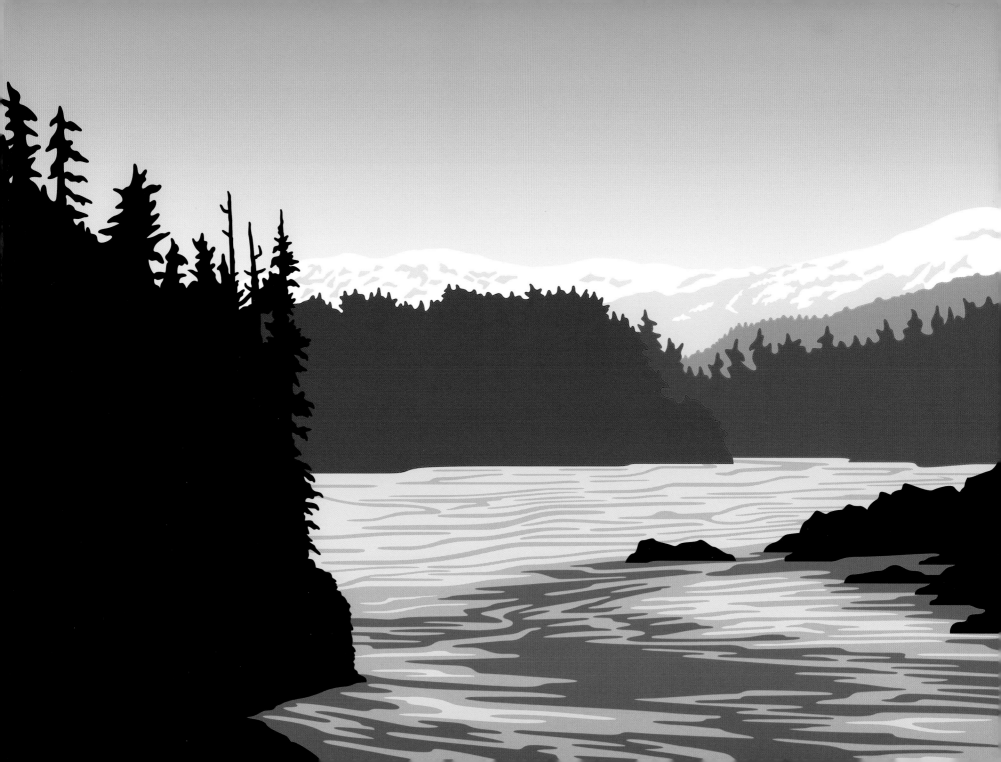

Acknowledgements:

Thanks to Colin Preston, CBC Vancouver Archives, Sheryl MacKay, Gary Mitchell, J. Robert Davison, Allen Specht, Charlene Gregg, Dennis Duffy, Ember Lundgren, Cheryl Linstead, David Lemieux, the families and descendants of Imbert Orchard and Ian Stephen, and the Royal BC Museum and Archives for their assistance with access and permissions. —RB

Thanks to my friend and mentor, Walter Harris, the longest standing Chief Qeel from Kispiox who adopted me and taught me much about Gitxsan culture, Ward Marshall, Neil Sterritt, Henry Vickers, Wilson Duff, Peter McNair, Hillary Stewart, Chester Bolton, Kenneth Spencer, Matthew Hill, Kathleen Collinson-Vickers, John Freeman, Chief Dan George, the Walkus family, the Humchitt family, Simon Charlie, George Clutesi, Mabel Williams, Henry Nolla, the Northwest Coast Indian Artists Guild, Vernon Stephens, Ken Mowatt and Victor Mowatt. —RHV

All of the audio in this book was edited by Robert Budd. The complete interviews from the Orchard Collection are housed at the BC Archives.

Harbour Publishing Co. Ltd.
P.O. Box 219, Madeira Park, BC, V0N 2H0
www.harbourpublishing.com

Edited by Lucy Kenward
Jacket and text design by Roger Handling
Printed and bound in China

 BRITISH COLUMBIA ARTS COUNCIL
An agency of the Province of British Columbia

Canada

Harbour Publishing acknowledges the support of the Canada Council for the Arts, which last year invested $153 million to bring the arts to Canadians throughout the country.

Nous remercions le Conseil des arts du Canada de son soutien. L'an dernier, le Conseil a investi 153 millions de dollars pour mettre de l'art dans la vie des Canadiennes et des Canadiens de tout le pays.

We also gratefully acknowledge financial support from the Government of Canada and from the Province of British Columbia through the BC Arts Council and the Book Publishing Tax Credit.

Library and Archives Canada Cataloguing in Publication

Title: Voices from the Skeena : an illustrated oral history / Roy Henry Vickers and Robert Budd.
Names: Vickers, Roy Henry, 1946- artist. | Budd, Robert, 1976- author.
Identifiers: Canadiana (print) 20190148810 | Canadiana (ebook) 20190148837 | ISBN 9781550178838 (hardcover) | ISBN 9781550178845 (HTML)

Subjects: LCSH: Skeena River Region (B.C.)–History–Anecdotes. | LCSH: Skeena River Region (B.C.)–History–Pictorial works. | LCSH: Skeena River Region (B.C.)–History, Local–Anecdotes. | LCSH: Skeena River Region (B.C.)–History, Local–Pictorial works.

Classification: LCC FC3845.S54 V53 2019 | DDC 971.1/85–dc23